THE ARTIST'S
DRAWING
BOOK

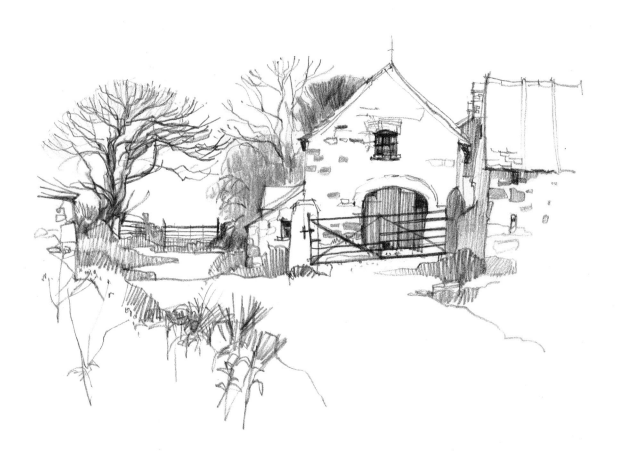

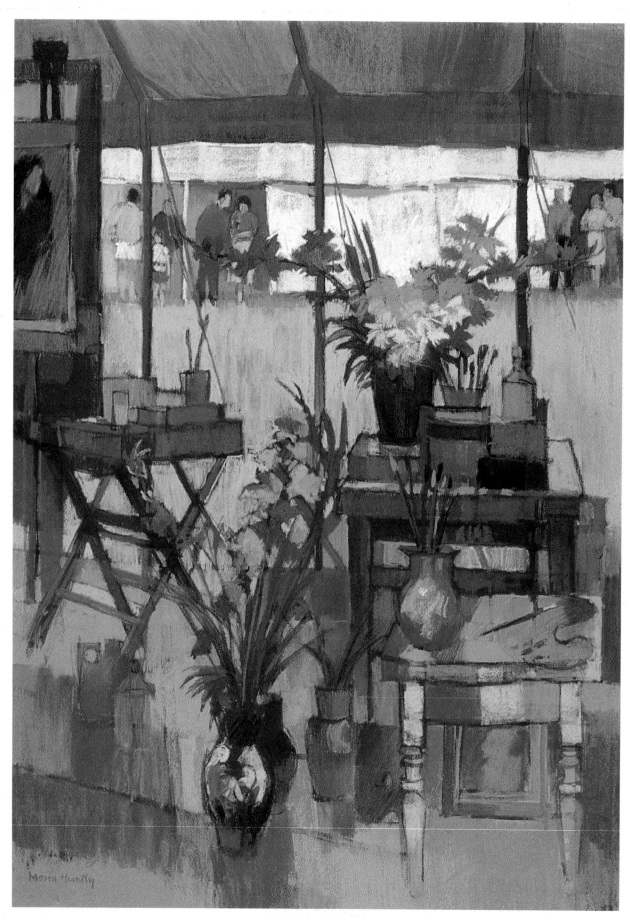

Roy's Group

THE ARTIST'S
DRAWING BOOK

MOIRA HUNTLY

Ty Canol, Wales

David & Charles

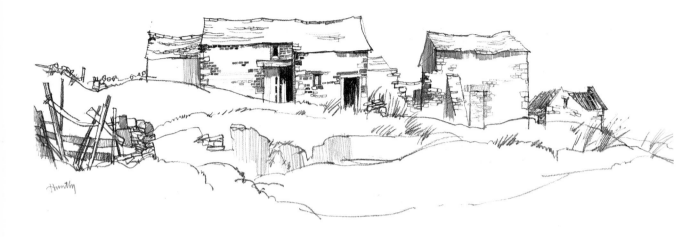

Farm near Rushworth Moor, West Yorkshire

A DAVID & CHARLES BOOK

Copyright © Moira Huntly 1994, 1997

First published 1994
Reprinted 1994
First paperback edition 1997

A catalogue record for this book is available from the
British Library.

ISBN 0 7153 0146 2 Hardback
ISBN 0 7153 0561 1 Paperback

Typeset by ABM Typographics Ltd, Hull
and printed in Italy
by LEGO SpA
for David & Charles
Brunel House Newton Abbot Devon

CONTENTS

INTRODUCTION

As soon as a mark is put on a piece of paper it starts to convey something, and I believe it is instinctive in all of us to want to make marks, however abstract, in order to express ourselves. It is natural for children to make doodles at an early age, then learn to represent shapes and form letters, and drawing is an extension of writing. Drawing helps to develop a physical co-ordination between hand and eye, and gradually we learn how to 'see'. It could be said that drawing is the art of seeing.

Included in this book are exercises in observation which aim to analyse how we can extend our vision and heighten our perception, and which examine the thought processes of drawing generally. But there is more to drawing than mere analysis – it is the way that marks are made, and the effect and suitability of the medium chosen, which creates something unique. Basically, this book is about putting ideas down on a flat surface using all kinds of different media, improving drawing skills and, at the same time, keeping an open mind receptive to new ideas.

Drawing, according to the dictionary, is the art of representing by line without colour or with a single colour as in a monochrome sketch, but the world we see around us is in colour, and so drawing in colour is a natural extension of the definition. Today, with a wide range of different media available, colour is no longer confined to monochrome or to adding colour notes to a sketch purely for information.

There are many reasons for producing drawings: in preparation for paintings and designs, as studies, for noting ideas, as roughs for compositions, reference drawings or simply drawings that are works of art in their own right, not produced for a particular purpose but made purely for the joy of drawing. There are so many things to draw and different ways to draw them. I used pen and ink and coloured felt-tip pens for the sketch of the Thames below, and black Conté pencil for the church on Anglesey (opposite). The full-colour drawing on deep blue paper on page 2, *Roy's Group*, was made in pastel. This was a very personal interpretation of the subject, seen from inside a marquee and looking out to the open area, with the 'studio' furniture and still-life groups appearing almost silhouetted against the light outside. I worked in various tones of blue, which con-

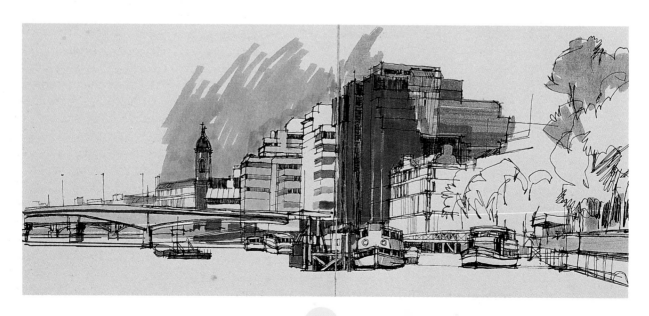

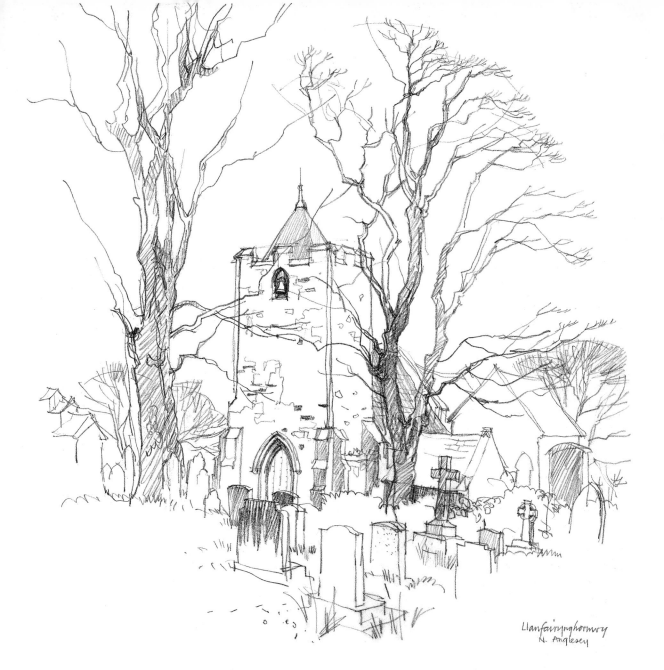

Llanfairynghornwy
N. Anglesey

Church at Llanfairynghornwy, Anglesey

This isolated church in the north of Anglesey, surrounded
by old trees, provided a good subject. A soft charcoal
pencil seemed the right medium in which to capture the
texture of the trees and ancient stonework.

◁ The Thames from Tower Bridge

This is a sketch-book drawing made across the centrefold
of the book. Its principal interest lies in the build-up of
the buildings leading to the tallest dark mass, which is
emphasised by being sandwiched between lighter
buildings. These big, modern, chunky structures contrast
with the thin, vertical church tower and with the
horizontal lines of the bridge and the boats. The sketch
was made with waterproof fibre-tip pen and with three
shades of grey felt-tip pen, overlapping in places to
create more subtle variations of grey. The distribution of
tone is important in producing an alternating pattern of
light and dark areas. Little touches of tan colour around
the boats provide a welcome contrast to the cool greys.

trasted intensely against the light, and then added a
few touches of pink, bronze and yellow to give
additional pinpoints of colour.

Good draughtsmen, like good musicians, develop
their skills with constant practice, so it is a good idea
to draw every day, if only for a few minutes. Having
a limited amount of time to spend on a drawing can
be good discipline, concentrating the mind and pro-
ducing a spontaneous, lively image – by focussing
on the subject, you forget yourself and do not worry
about the end result. It is also good sometimes to be
able to take time over a drawing, looking and check-
ing as the work progresses and not just at the finish.
However, a 'too finished' drawing is in danger of be-
coming nothing more than tedious technique. As a
student I was expected to spend all day drawing from
the classical casts in what we called the 'antique
room', and this did not always lead to exciting or

intimately personal drawings – sometimes the drawings, in keeping with the casts, lacked life. In contrast to this, look at the quick little sketch opposite of groups of constantly moving figures, which was made to supplement the very large-scale pastel drawing of the painting demonstration area inside the marquee (opposite).

Sketch books are essential to the artist, full of ideas, beginnings and a store of information for future paintings. The directness and personal nature of sketch-book drawings also make them enormously attractive to the viewer, sometimes more so than a completed painting.

Drawings, of course, often form the basis for paintings. My sketch-book drawing of Birdham was an instinctive choice of viewpoint, providing me with many of the abstract design and pattern elements I seek as a painter. It is up to each individual to decide what he or she wants to express, to keep a personal vision and a free approach and, through observation and the act of drawing, become more familiar with the world around us.

The Painting Tent ▷

This very large pastel drawing of the inside of the marquee was made on bright orange Canson Mi-Teinte mountboard, which gave a different interpretation to the scene to *Roy's Group* (page 2). Here, the warm ground permeates the pastel work, creating a warm light and atmosphere.

Birdham ▽

This sketch was made with a drawing pen and black felt-tip pen, producing a variety of thin and thick lines. I chose an interesting vantage point at the end of the gangway leading to the dark building, with its variety of window shapes on different levels, and the lettered signs. These provided a strong design element, and such elements can form a good basis as inspiration for a future painting.

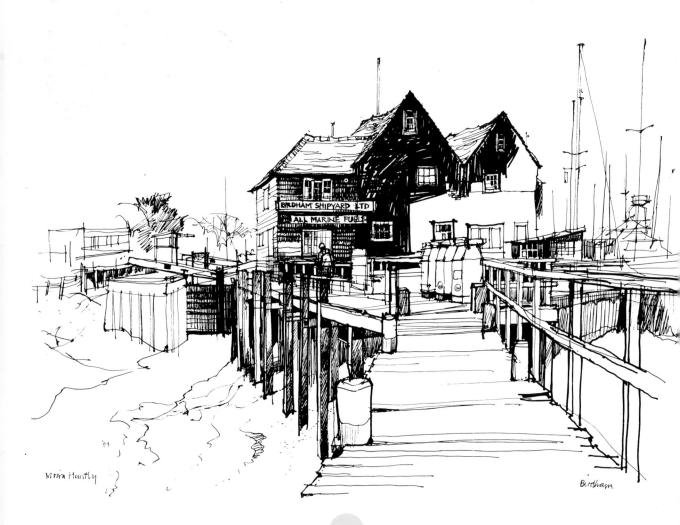

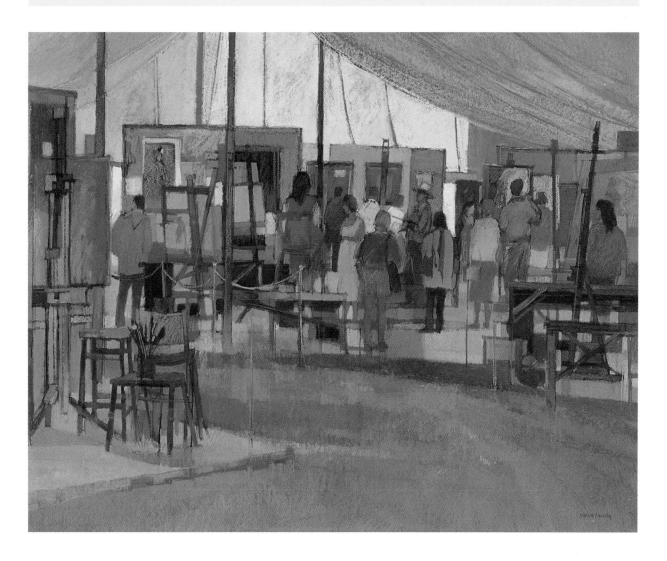

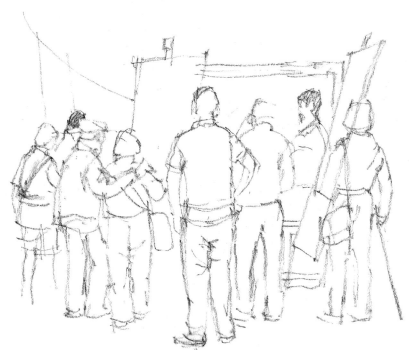

1
MATERIALS

Supports

Most of the types of support I have used throughout the book are shown opposite, but there are other supports available to the artist which are not included. The support obviously has an effect on the marks made by the media used, and by trial and error you can discover what suits your individual needs, so it is well worth experimenting for yourself.

Supports offer enormous potential in creative drawing, providing for a variety of effect and expression. The texture as well as the tone of paper affects the character and appearance of line work: a paper with a rough surface, for example, gives added texture to a drawing. In addition, different techniques suit different papers: a pen works best on a fairly smooth paper or board, otherwise the nib can catch and be distorted if the surface is rough; line and wash techniques work well on Bristol board, HP watercolour paper or heavy cartridge paper. If the paper is large or thin it may need stretching beforehand, whereas a heavy paper will not.

Working on toned paper can give harmony and subtlety to a drawing and is particularly suited to pastel, sanguine and charcoal (the paper usually has a grainy surface with a tooth which will hold pastel well). The tint shows through and becomes an integral part of the drawing, providing a colour emphasis, perhaps a warm or a cool tone, or a very dark tone which will contrast well with a colourful drawing. The pastel drawing of *The Painting Tent* on page 9 was carried out on a large piece of bright orange Canson Mi-Teinte board, a vivid ground which permeated the whole drawing, giving a warm atmosphere to the interior of the tent. When working on a coloured ground, it is advisable to choose good-quality coloured papers and boards that are light fast.

It is rewarding to create your own coloured grounds to work on; these can be permanent and varied. I have carried out drawings on watercolour washes and thin acrylic washes, and these grounds, if carefully selected, can become an integral part of the image. If you are working with a dry drawing medium, it is wise to allow a prepared support to dry thoroughly before commencing work.

Drawing can also be incorporated with collage and I keep a selection of textured, coloured and patterned papers for this purpose.

Paper and mount (or mat) board can be obtained in different sizes, and the maximum size manufactured dictates the maximum size of a drawing; however, for those who like to produce large-scale work some papers can be purchased by the roll.

The rest of this materials section deals with the various drawing media but, as we have seen, the support used is of vital importance, and each medium will produce different results on different surfaces.

PAPER

Paper has three types of surface:

* HP (hot pressed)
* NOT (cold pressed)
* Rough

The three most popular weights are:

90lb (185gsm)

140lb (290gsm)

200lb (425gsm)

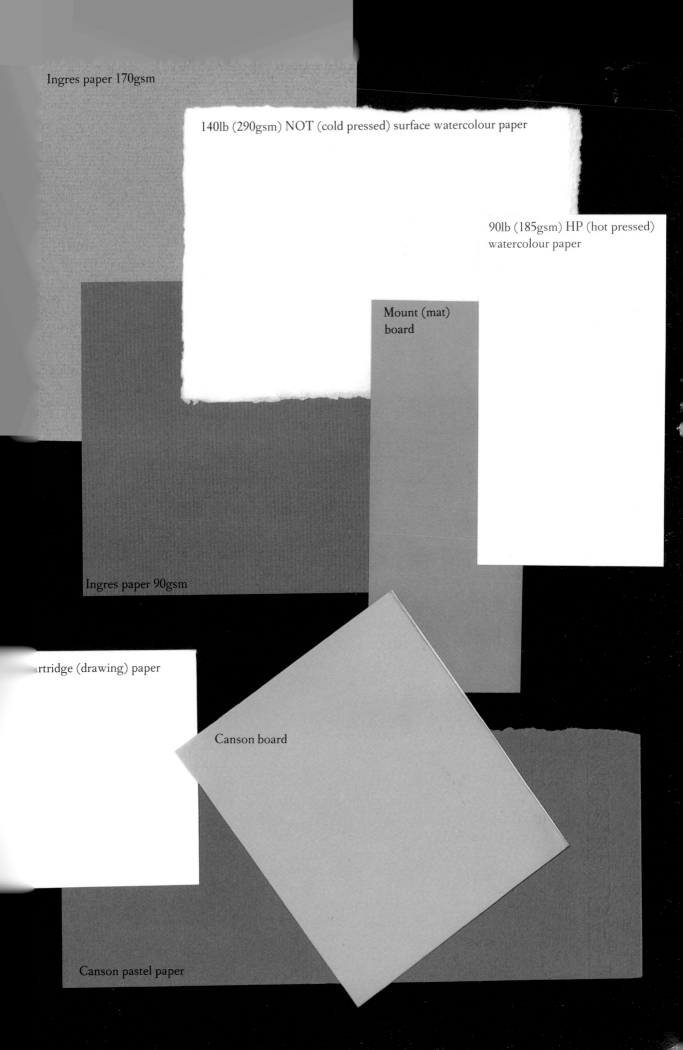

Ingres paper 170gsm

140lb (290gsm) NOT (cold pressed) surface watercolour paper

90lb (185gsm) HP (hot pressed) watercolour paper

Mount (mat) board

Ingres paper 90gsm

rtridge (drawing) paper

Canson board

Canson pastel paper

Fine Marks

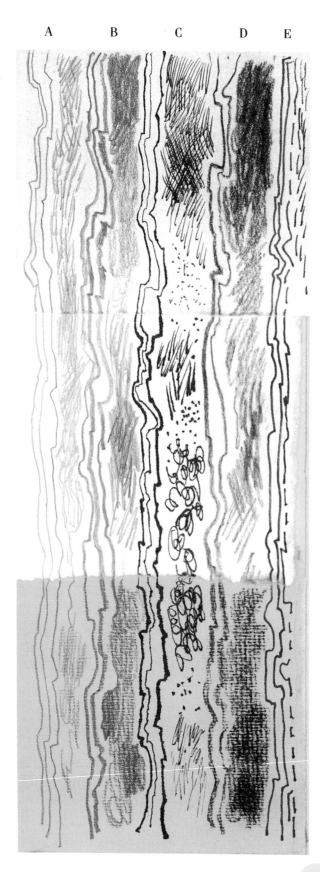

A B C D E

Through drawing with various media on different supports, you will discover in time what best suits your style and your purpose. I have chosen four supports to demonstrate some of the changes which take place in the character of the line as it progresses over the different surfaces. On this page, cartridge paper is at the top, smooth HP watercolour paper in the centre and textured Ingres paper at the bottom, and on the page opposite there is black Ingres paper with white drawing media.

A and B: We start with *pencil*, since it is probably the most commonly used drawing tool today. A wide range of graphite pencils is available, from very hard to very soft, and these can produce a wide range of effects. General areas of tone can be created by hatching, cross-hatching, rubbing, or by the use of different grades of pencil from 4H (very hard) through medium to 6B (very soft). The two grades shown here are HB (A) which is medium hard, and soft 4B pencil (B). The harder pencil has a fine, precise line and the shading is soft toned. The 4B pencil has a greater tonal range and a soft-edged character to its line.

Smooth paper is probably best for pencil drawing, though interesting effects can be gained on other surfaces; for example, both pencils show textural effects on Ingres paper, the softer pencil to a greater degree than the harder.

The tone of an individual line can be varied with pressure or by erasing gently. Broad areas of tone can be achieved by sharpening the pencil to a point which is long enough to enable the side of the lead to be used to fill the space. When pencils are worn down to a stub which is too short to handle easily, their life can be extended by using a pencil holder.

C: These doodles are made with a *dip pen and black Indian ink*. Nibs are available in various sizes, and their flexibility allows for sensitivity and subtlety in line work. Pen and ink has been used for hundreds of years, and in the past drawings were often made with pen and bistre, a brown pigment made from charred wood and used as ink or as a wash, creating a warm tonal study in monochrome.

The character of the pen line varies with pressure and the amount of ink on the nib – with experience you will sense when the ink is going to run out. Drawing with a pen is very direct and seldom possible to erase, so some bravado is required, but the spontaneous, free-flowing lines – even the odd blot – give a vitality to the work. Tone can be created with hatching, cross-hatching, dots and scribbles.

A smooth surface is best for pen work, either cartridge paper or Bristol board. Here you can see that the pen line has become diffused and has soaked into the watercolour and Ingres papers. The nib may catch on a rough paper, and the line can be difficult to control.

Pen and ink combines well with other media such as watercolour, gouache and chalk, and is a particularly good medium for illustration work, as well as for rapid sketching. For complicated drawings, a preliminary light pencil line may be required as a guide. Allow the ink to set for several hours until it is totally dry before any pencil lines are rubbed out.

D: I have included *Conté pencils* in this fine-mark section, but they will only make fine marks if you keep them well sharpened. This is because they are relatively soft and the point quickly wears down to give a coarse, smudgy line. This characteristic can, of course, be utilised in a drawing and act as a foil to fine lines.

Most surfaces are suitable to work on; the line varies with pressure and tone is created with hatching and by blending into the paper. The texture of the paper is clearly obvious on the Ingres paper at the bottom, but the grain can be filled with extra pressure. All soft pencils smudge easily and will offset on to the next page in a sketch book, so it is advisable to use a fixative.

E: More pen lines. Here I have used a *fibre-tip pen*. These are very useful for sketching but they give an even, mechanical line, the quality of which is not so interesting as a dip-pen line. Some of these pens are not waterproof or light fast, and if you use them for reproduction drawings and wish to make alterations, the ink tends to bleed through process white.

Reservoir pens such as Rotring use permanent ink and are better for illustration work. These pens also produce a mechanical line, but the large choice of nibs makes them very versatile.

These doodles were made on lightweight black Ingres paper.

F: *Dip pen and white ink* is at its most effective on a black background. All the line work has been produced with the same nib, the amount of ink and pressure giving varying character to the line. Light tones are created with cross-hatching and dots.

G: *White Conté pencil* produces a coarser line and does not cover the black ground as completely as white ink, so the white is less intense. The line varies with pressure, and a subtle gradation of tone can be achieved.

F G

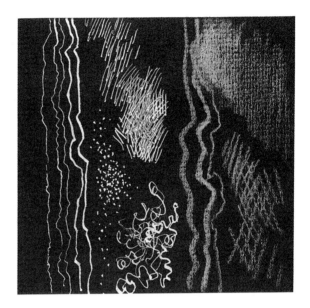

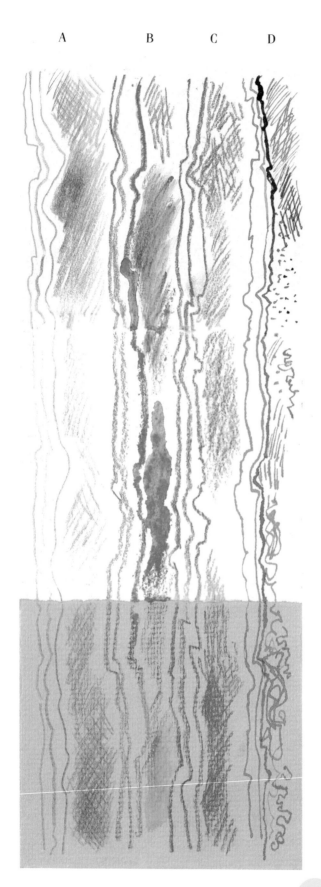

A B C D

FINE MARKS IN COLOUR

A: This first example shows *coloured pencils*, and it is clear that a white ground is most effective and that the best surface is the smooth cartridge paper at the top. Coloured pencils are difficult to use on textured papers; the NOT surface watercolour paper shown in the centre tended to resist the waxiness of the pencils, and any pressure created an indentation in the paper. The Ingres paper was also difficult to work on and the grain appears very prominent, creating an optical colour mix with the pencils.

B: This is a *water-soluble coloured pencil*. Less waxy and producing a stronger line than ordinary coloured pencils when worked dry, it glided easily over all three types of paper, but a more precise line was achieved on the smooth paper. By dipping the tip of the pencil into water and drawing with a wet point a darker-toned, thicker line was obtained. Areas of shading can be softly blended and washes created by working over the pencil with a damp brush.

This versatile pencil spans the division between fine point marks and wet media effects, and the combination makes it a useful medium for sketching.

C: *Pastel pencils* are pastel in a hardened form and can be sharpened to a point. They are sensitive and versatile drawing tools, which combine well with other media such as watercolour and are used to add finishing touches of detail to pastel work. The quality of line responds to pressure, and this works well on all papers. Shading and hatching is very coarse on the NOT surface watercolour paper but blends well on the Ingres paper. Pastel pencils are very fresh on white paper and are also ideally suited to coloured grounds.

D: Drawing with a *pen and coloured ink* can be exciting, but it should be pointed out that most coloured inks are not light fast and will fade in time. Again, the most precise line is achieved on smooth paper. The NOT surface watercolour paper used here was so rough that the nib tended to catch, making this an unsatisfactory support.

Broad Marks

Charcoal is the oldest and softest of the dry drawing media, and is available in sticks of various widths. It is an ideal medium for giving impressions of tone, varying with the pressure used and the softness of

the stick, and is good for use in large-scale work. Preliminary tonal sketches to work out compositions for painting are often made with charcoal, which can be altered easily as drawing progresses: lightly applied charcoal can be wafted off with a rag and darker areas can be removed with a soft putty eraser. Because of its softness charcoal can easily smudge, so a finished drawing is in a delicate state until it has been fixed. Sometimes it is necessary to give more than one spray.

The best surfaces for charcoal drawings are smooth cartridge paper, pastel paper or Ingres paper, while drawing techniques can include hatching, shading with the side of the stick, blending with the fingers or a torchon, and working into areas of tone with an eraser. Charcoal combines successfully with other media including watercolour, pastel, ink and collage.

E and F: These examples show charcoal marks on cartridge paper and on a mid-tone pastel paper. The marks on the left demonstrate that fine lines can be achieved with very thin sticks of charcoal; the central marks were produced with a medium-size stick, and those on the right were made using a large, square stick of charcoal. Techniques include cross-hatching, shading and blending, and the texture is most apparent on the pastel paper.

G: Candle wax is initially an invisible drawing medium, the results appearing like magic only when watercolour or dilute ink is washed over it. The medium relies on the principle that the greasiness of the wax will repel water, so that when it is applied to the paper it will act as a resist. Only a few beads of wash will adhere to the wax, and this creates interesting globular textures. The quality of the line is very broad and coarse and not always easy to control, but the effect is lively and spontaneous. To a certain extent, it is possible to view a colourless waxed area before applying a wash by holding the paper at eye level and looking along the surface, tilting it until the light shines on the wax.

H: Both the wax doodles have been made on HP watercolour paper, but wax can be applied to any paper, depending on how textured you want the line to be. Here *candle wax* has been applied on top of a wash, and then a second wash has been brushed over the image. The process can be repeated several times, but each wash must be completely dry before any wax is applied.

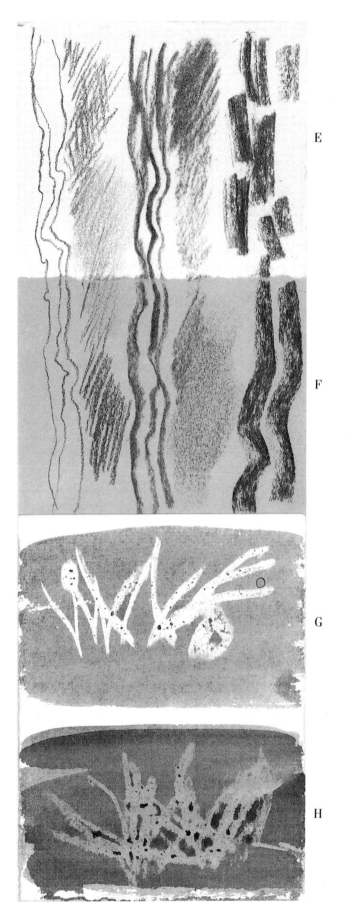

E

F

G

H

BROAD MARKS IN COLOUR

A: These marks were made with *oil pastel* on heavy cartridge paper. The sticks are greasy and can feel sticky to draw with, so they are more suited to broad effects than detail, but the medium can produce an intensity of colour and vibrant effects. Colours can be mixed on the paper by laying one colour over another; they can also be blended using a brush dampened with turpentine. Line work varies slightly with pressure.

B and C: This is *soft pastel*, another vibrant medium that can produce intense clarity of colour, as the particles of pigment adhering to the surface will reflect the light. Drawing can be carried out with the tip or the side of the pastel stick, mixing on the paper by cross-hatching or laying one colour over another, and blending with the fingers or a torchon. Supports play an important part in pastel drawing, which requires a tooth to hold the particles. Various pastel and Ingres papers and boards are available, with different degrees of texture and in a wide range of colours. The colour choice of support has a strong influence on the colour impact of the final drawing: here, you can see that yellow pastel appears to be a bright colour when applied to the blue pastel paper, whereas on the grey paper it is more subtle. Similarly, the effect of olive green is more striking on the grey pastel paper than on the blue. Pastel is one of the most permanent of media but it can smudge, so it is advisable to give it a light spray of fixative and keep the finished work behind glass.

D: These doodles were made with *wax crayons*, which are also greasy and act as a good resist in mixed-media work. On the whole, the colours are not as brilliant as oil pastel.

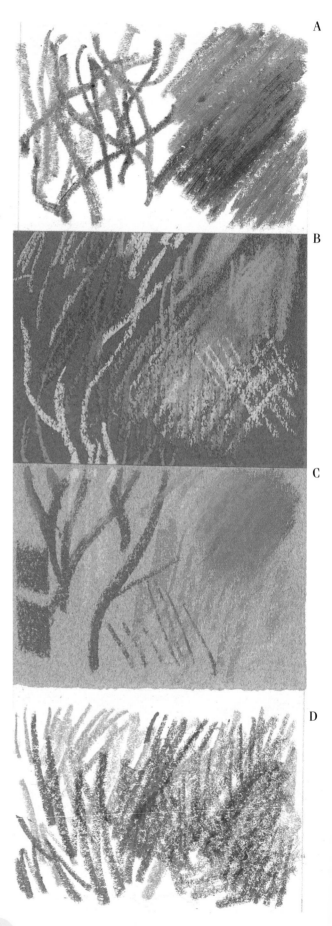

A

B

C

D

Wet Media

Drawing and writing with a brush is an ancient art which has been practised by the Chinese and Japanese for hundreds of years. A brush is a sensitive and manipulative tool and a variety of marks can be made, depending on the size and shape of the brush and how you hold the brush to the paper. The wet media used here include watercolour, gouache and ink, and the marks were made with No 1 and No 5 round sable brushes.

E: These freely drawn brush doodles were made on *cartridge paper*. The fine lines were achieved by holding a No 1 brush upright with the tip pointing down on to the paper, while the broader marks were made with the brush held more horizontally to the paper. Variations in the width of line were achieved by changing the pressure.

F: Here the brush lines were made on *NOT surface watercolour paper*, and the strong texture creates a broken-edged quality of line. The colour quickly runs out of the brush, leaving a dry-brush texture.

G: Watercolour on *toned Ingres paper* sinks in and is affected by the colour of the support. Here, the blue appears to be a different shade and the red is lower in tone than on the white supports. Fine white brush-drawn lines are made with gouache, diluting it for more subtle effects as with the broader brush marks.

H: This example shows brush drawing with black Indian ink and gold ink on a *smooth HP watercolour paper*, but any paper surface can be used. For some of the line work the black ink has been diluted with water, giving a subtle grey line, and the brush line at the bottom right-hand corner was worked on damp paper, causing the line to flare and become fuzzy in character.

2
APPROACH TO OBSERVATION

This chapter concentrates on observation and draughtsmanship, and attempts to analyse the action of 'seeing', but it should be remembered that there is more to drawing than mere accuracy. Good draughtsmanship alone is not enough – that is the craftsman side of drawing – and we also need to express the creative and imaginative aspect.

It is through drawing that we learn to see and record everyday objects with a fresh eye and gain a new vision of the world around us. Sometimes unlikely subjects become surprisingly interesting through the process of drawing.

The exercises in observation that follow are fairly academic in approach, but without going into the details of anatomy or perspective. Learning about proportion and training the eye through drawing nature, figures or arranged objects is the backbone of painting, and is as valid for the freedom of approach today as it was in the days of Leonardo da Vinci.

To begin with, let us look at some practical aspects of setting up. Try to work with your board in a vertical position, and place yourself so that you have enough room to draw from the shoulder and to step back and view both the subject and your drawing at the same time. This enables you to make comparisons, while using the whole arm helps you to draw freely and lessens any tension. Drawing is not like writing, so there is no need to grip the drawing tool tightly, rather the opposite: hold the tool loosely and be prepared to change your grip. Draw lightly to begin with, without an eraser, and then firm up on the lines you want. Spend time looking,

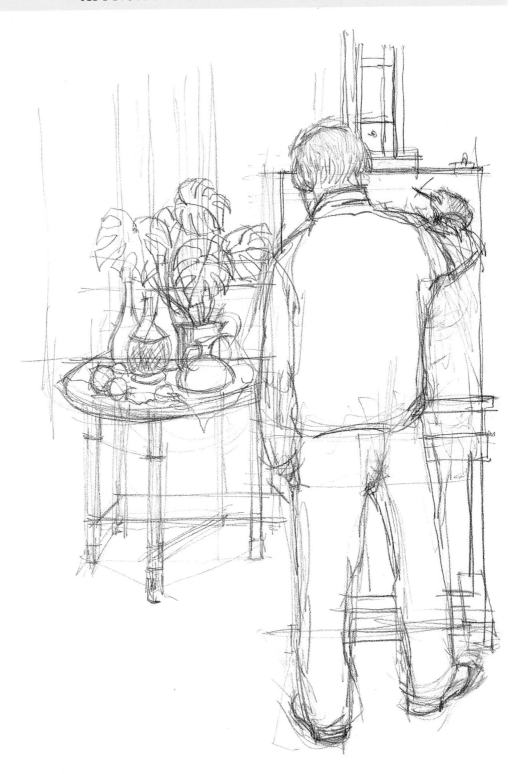

measuring with the eye, calculating distance, comparing one measurement with another, and looking for reference points in line centrally, vertically and horizontally.

All these points are referred to in the observation exercises. Above all, do not feel you must produce a good piece of work every time you draw, as this is actually highly unlikely – be prepared for many disappointments along the way.

Measuring with the Eye

Measuring with the eye is a natural habit which we automatically practise every day without thinking. Car drivers are constantly calculating distances and judging the area of a parking space, or we may have to divide a cake into equal portions, or hang a picture on a wall. We are immediately aware if the picture is hanging crookedly – our eyes and inner sense of balance unconsciously give us this information. Drawing helps to develop an awareness of measuring by eye.

The observation exercise below is very simple, but it also involves some control in drawing vertical and horizontal lines freehand, as well as accuracy in gauging dimensions.

Fig 1: Place the drawing board in an upright position and, with the pencil held at arm's length, draw a horizontal line. For this example I have made the line 15cm (6in) long, but this is arbitrary. Calculate the centre point of the line by eye and make a mark, then check with a ruler. It is surprising how accurate you can be.

Fig 2: Calculating by eye, and without using a ruler, draw two horizontal 7.5cm (3in) long lines side by side.

Fig 3: Draw a 7.5cm (3in) horizontal line and then a 3.75cm (1½in) line alongside. In doing so, glance at the 7.5cm (3in) line and judge the centre point, mentally assessing the width of the half line before drawing.

Fig 4: Once again, draw a 7.5cm (3in) line, but this time also draw two vertical 3.75cm (1½in) lines at the side.

As the exercise progresses you will begin to develop an instinct for drawing the length of line accurately each time, but keep a check on yourself occasionally with the ruler.

Fig 5: Draw a square in the sequence shown. In order to assess by eye the length of line 2, imagine a 45° line that would join lines 1 and 2.

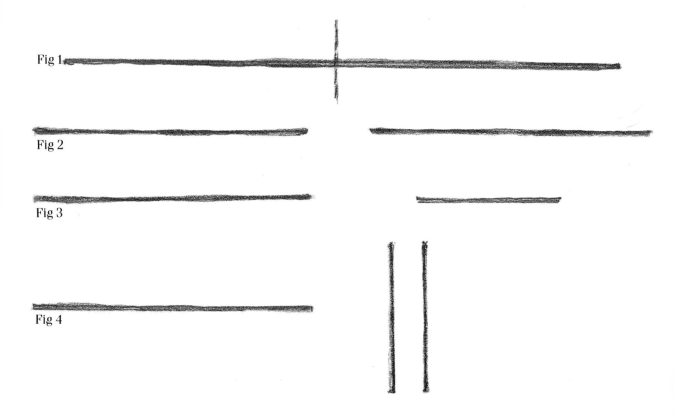

Fig 1

Fig 2

Fig 3

Fig 4

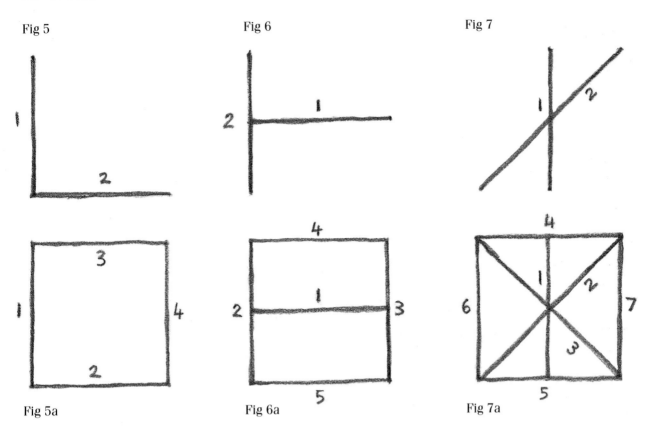

Fig 5 Fig 6 Fig 7

Fig 5a Fig 6a Fig 7a

Fig 5a: Continuing the square, control is required in drawing line 3 parallel to line 2, and ending precisely above the end of line 2.

Fig 6: Making a square in this order can create an optical illusion: line 1 appears to be longer than line 2.

Fig 6a: Again, care is required to commence line 3 horizontally opposite and then to draw it parallel with line 2.

Fig 7: This is a more complex and therefore more difficult exercise. First, judge the centre point of line 1 and then draw a 45° diagonal line through it, starting on a level with the top of line 1 and finishing level with the bottom of line 1.

Fig 7a: You will find that several horizontal and vertical mental references will be required to complete this square with accuracy.

PRACTICAL APPLICATION

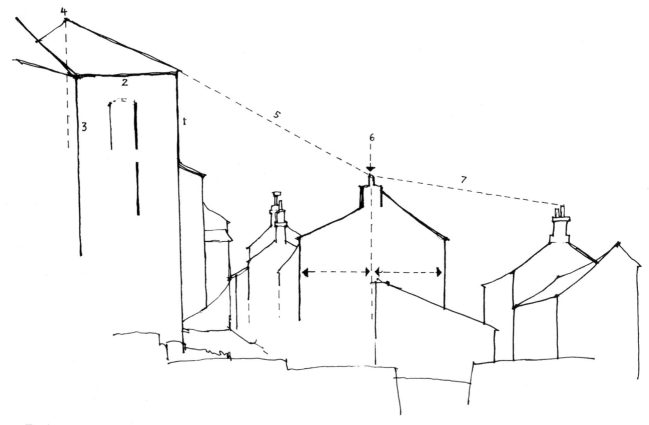

Fig 1

Training the eye to estimate distances and angles and compare measurements applies to drawing all subjects. Here I have chosen buildings as an example of practical application. The diagrams are based on the drawing shown overleaf, and their aim is to define the thought processes.

Firstly, where on the paper do you start? I looked at the shape of the whole group of buildings and tried to estimate the area of paper the general shape would occupy, noting the highest and lowest points.

Fig 1: The drawing commenced with line 1 to establish the height of the tallest building. Line 2 then established its width, which was compared to its height, and line 3 was drawn parallel to line 1. The angle of this roof and the position of the apex (4) in relation to line 3 quickly followed. Once these lines were placed they became reference points for all the other buildings.

The chimney of the central building was placed next, estimating by eye the angle between the chimney and the height of the first building (5). Again measuring by eye, I realised that the chimney breast was central but the unusual roof line, with the rear roof at a different angle to the front roof, created the illusion that the chimney was off centre (6). The next angle to be perceived was that between the centre chimney and those on the right-hand building (7), and gradually the intervening buildings were added.

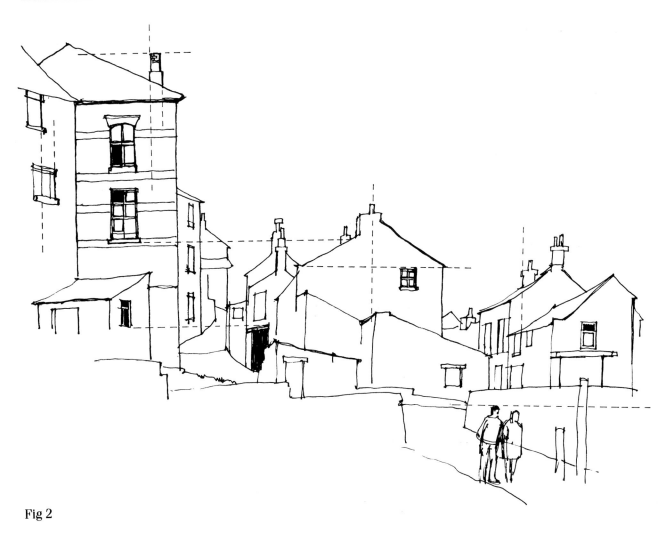

Fig 2

Fig 2: As the drawing progressed, measuring by eye was also applied to the details, such as the proportion of the window panes and how the horizontal stone courses on the tall building compared with the position of the window panes etc. The height of the figures was estimated and the level of their heads related to the harbour wall and mooring posts.

Many of the horizontal and vertical comparisons were checked by using the top and side edge of my sketch book as a guiding reference. I hold the sketch book vertically in front of me and move it along to verify what falls in line vertically, and move it up or down to check items on the same horizontal plane.

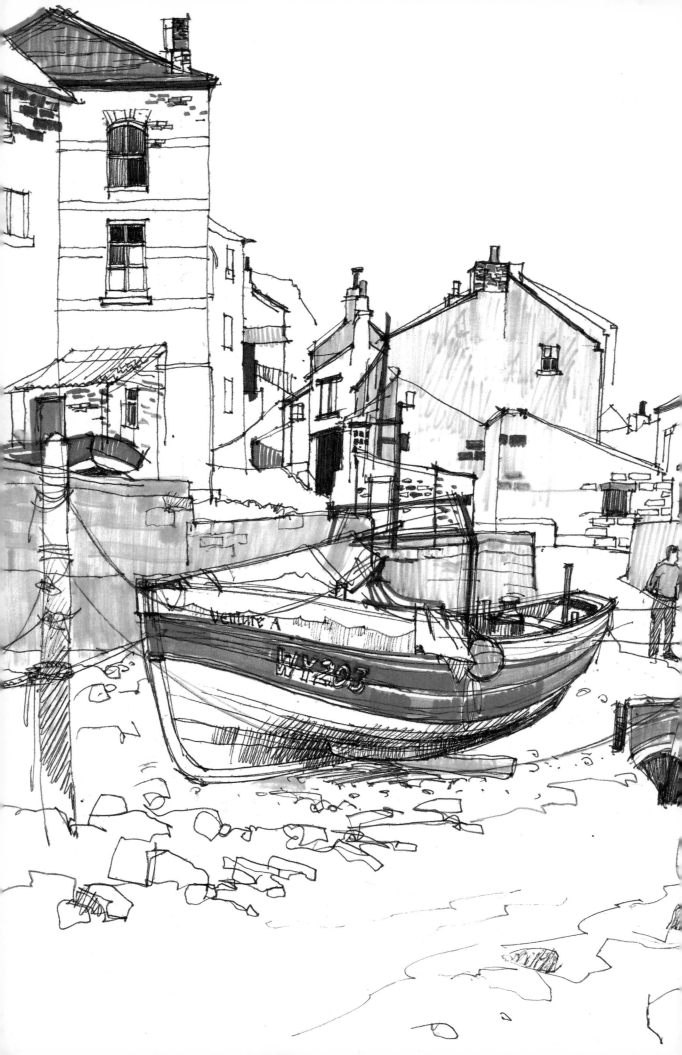

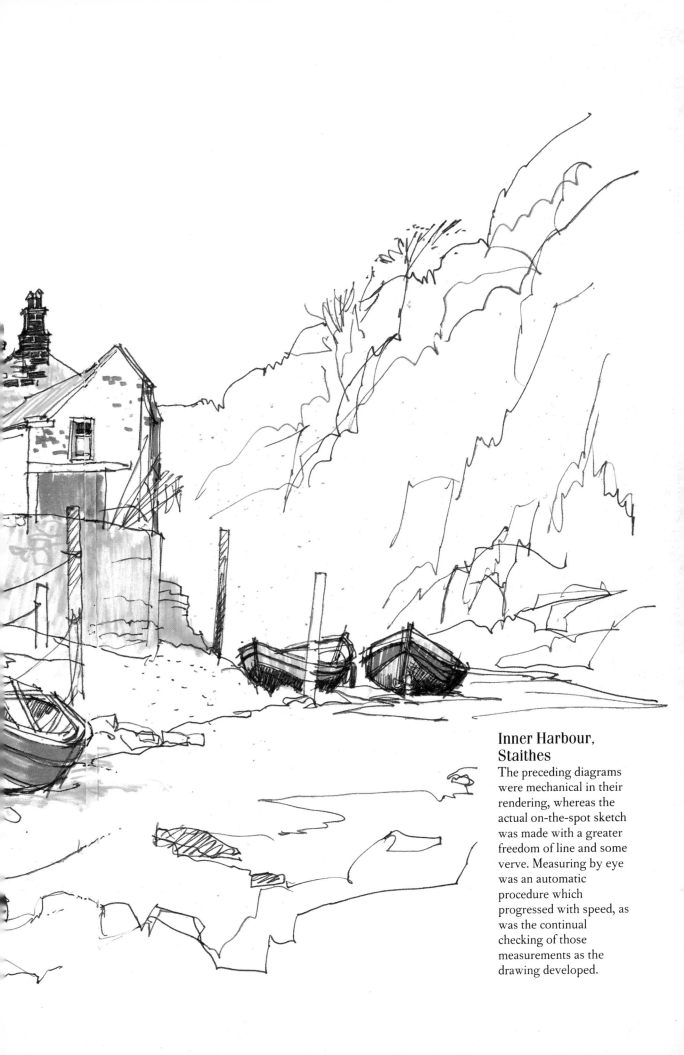

Inner Harbour, Staithes

The preceding diagrams were mechanical in their rendering, whereas the actual on-the-spot sketch was made with a greater freedom of line and some verve. Measuring by eye was an automatic procedure which progressed with speed, as was the continual checking of those measurements as the drawing developed.

Points in Space

This is an exercise in observation where the subject matter is purely abstract, thus concentrating the mind solely on accuracy. Normally, we look at the mass of an object and judge its overall shape, but this exercise has no such form – just pinpoints. It is possible that the outer points will form a shape in the mind's eye.

Learning to 'see' is difficult, and sometimes too much knowledge is a distraction. For instance, when drawing a table we know that perspective is necessary to create the illusion of a third dimension on the paper, and may find the thought of having to work this out rather frightening. An alternative method is to have a detached approach to drawing the table, by making a careful assessment of the position of each corner, indicating them as a dot and then joining them up. If accurate, this should produce a table top which is perspectively correct. There are guidelines to help us to see accurately: the position of points can be judged by relating them horizontally and vertically, and by noticing how each point may differ from the horizontal and vertical guides. By this

Fig 1

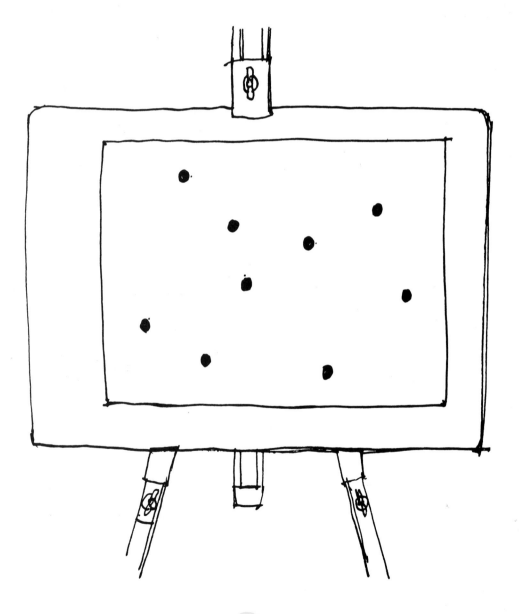

method it is possible to produce an accurate drawing and arrive at perspective without any theoretical knowledge. Ideally, however, coupling observation in abstract terms with a knowledge of perspective will become an instinctive path to good draughtsmanship.

Fig 1: Attach a sheet of paper to a drawing board and press in drawing pins at random. These represent an abstract placement of points. Place the board in an upright position directly in front of you before commencing to draw. Observe carefully and decide where to start, perhaps at the outer points to give an overall sense of shape, or maybe with the points nearest the centre, then working outwards.

Fig 2: Wherever you start, each point should relate to the edge of the paper as well as to the other points. Notice which point is closest to each edge of the paper, and use horizontal and vertical comparisons to see which, if any, are in line. In order to do this, close one eye and hold a pencil or plumb line in front of you at arm's length to check verticals, a pencil for horizontals. A plumb line is easily made from a thin piece of string with a weight attached to the end and makes a very accurate gauge.

Fig 3: Some of the points on the drawing have now been joined up to make triangles, and this helps to clarify the positioning of all the points. Observe the board again carefully and try to visualise the corresponding triangles, and see how they compare with your drawing.

Fig 4: Joining the outer points in this case produced a hexagon, and joining the inner points created many more triangles, all of differing shape. Examine each triangle in turn: they may be acute angled, long and narrow, or wide angled in appearance. The final test of accuracy becomes apparent if you join the points on the board with a line or black thread and then make a comparison with your own drawing.

This is a difficult exercise in observation so do not be too despondent if your first attempt is totally inaccurate.

It can be interesting to continue to join up every point and create an abstract form with many facets, like a diamond. The effect can sometimes be three-dimensional.

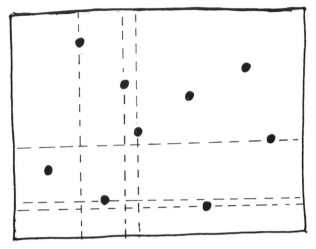

Fig 2

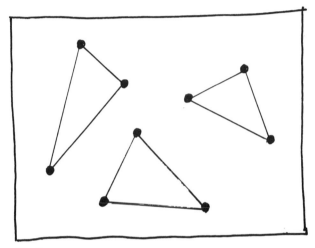

Fig 3

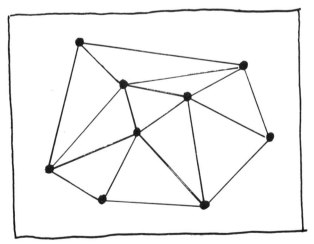

Fig 4

PRACTICAL APPLICATION

In all good draughtsmanship it is necessary to learn to see relationships between imaginary points, and plucking imaginary points out of mid-air is particularly apt when it comes to drawing portraits – inaccurate placing of points by even a small amount makes the portrait look like someone else. Learning to see, for instance, an imaginary triangle between the outer corners of the sitter's eyes and the tip of the nose, and then assessing what kind of triangle it is, comes with practice. In the diagrams shown here the progression of points has purposely been made obvious, but in an actual drawing construction lines and points are only lightly indicated and will disappear within the drawing.

Fig 1: The drawing was started by indicating the general shape of the head on the paper, while at the same time looking for subtle changes of angle. This was quickly followed by placing the level and width of the shoulders relative to the head. A three-quarter view made it tricky to identify the position of the triangle of points between the eyes and nose, and it is noticeable that the triangle is unequal. The lobe of the ear and the chin were also key points to observe and were pinpointed relative to the other dots.

Fig 2: The position of the ear, inner corners of the eyes and outer corners of the mouth were pinpointed in relationship to each other and to previous points, aligning them both vertically and horizontally. The tilt of the eyebrows, angle of the nose and position of the nostrils were all observed by the same method of comparisons.

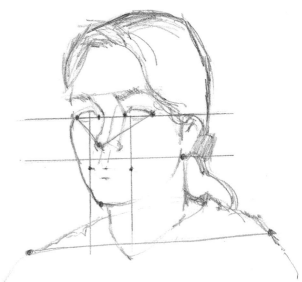

Fig 2

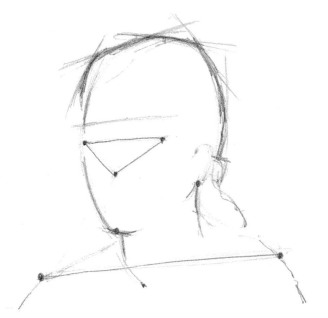

Fig 1

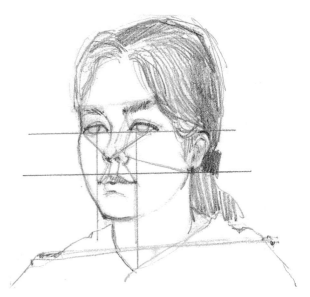

Fig 3

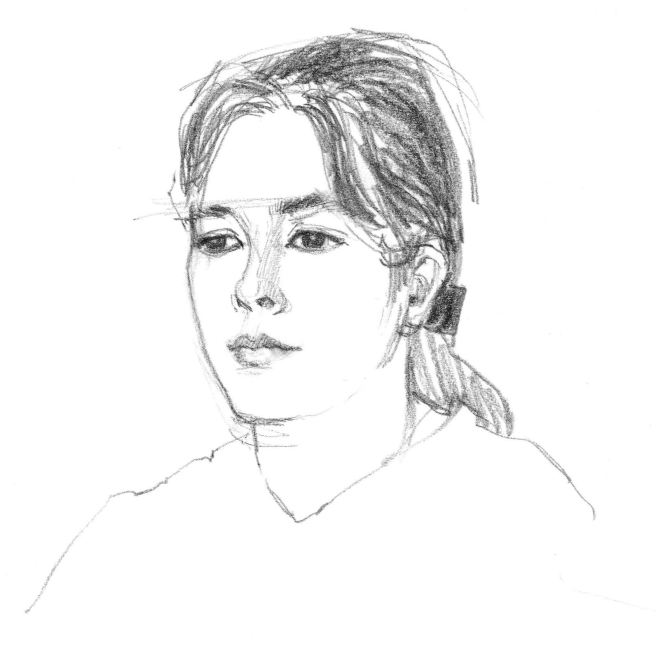

Fig 4 Carina

Fig 3: Details were gradually added to the head without losing any of the initial structure. Diagrammatic lines on the drawing show the thinking as the relationship between each feature was observed, a process which eventually becomes automatic as experience is gained.

Fig 4: This small sketch of Carina was made quite rapidly with a 3B Conté pencil. A few faint construction lines can still be seen, but are an acceptable part of the drawing.

Shape and Tone

Fig 1

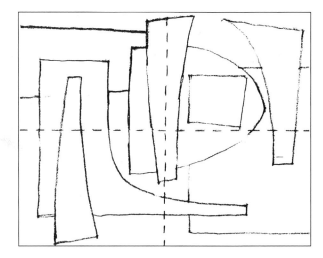

Drawing from abstract shapes is a useful exercise for concentrating observation on subtle curves, dimensions, the relative positions of each piece and their relative tones. Here, I made a simple collage of paper shapes based on three tones, black and white (the extreme opposites of the tonal range), and donkey brown as the mid-tone. More elaborate collages with a greater range of tonal values can, of course, be attempted and very interesting, inventive drawings can be made from them. In the process, many of the principles of the previous exercises in observation will come into play.

Calculating by eye, I divided the image into four equal quarters (Fig 1) then, as an example, I drew the top left-hand quarter (Fig 2) and the bottom right-hand quarter (Fig 3). Critical observation is required to produce these quarter drawings, mentally measuring the distances between shapes and comparing the vertical and horizontal lengths of each shape. To do this, I found it helpful to cover up the other three quarters of the image.

Fig 2

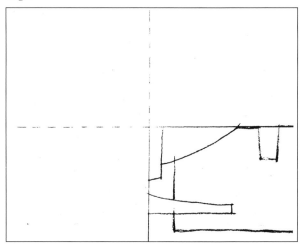

This process, in addition to being an exercise in developing observation, can also be a useful tool in enlarging a drawing, for instance on to a canvas, as an alternative to squaring up fully. Here again, I cover three-quarters of the drawing and concentrate on the important divisions in the composition of the visible quarter; then that quarter is covered and a different quarter uncovered, and so on until the whole image has been transferred by eye. When each quarter is complete, the image is viewed as a whole, and adjustments made where lines do not quite correspond.

Fig 3

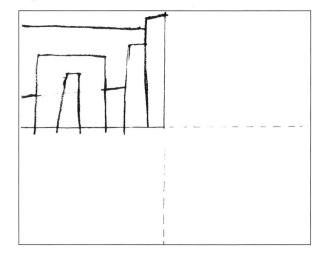

When drawing one shape you also have to look at the adjacent shape or the space between, which is the negative shape. In this collage, the white background paper registers as the white negative shapes in the composition, and in drawing these white spaces you are also defining the brown and black shapes.

A further check on accuracy can be made by turning both your drawing and the collage upside-down and making a comparison. Discrepancies immediately become more obvious.

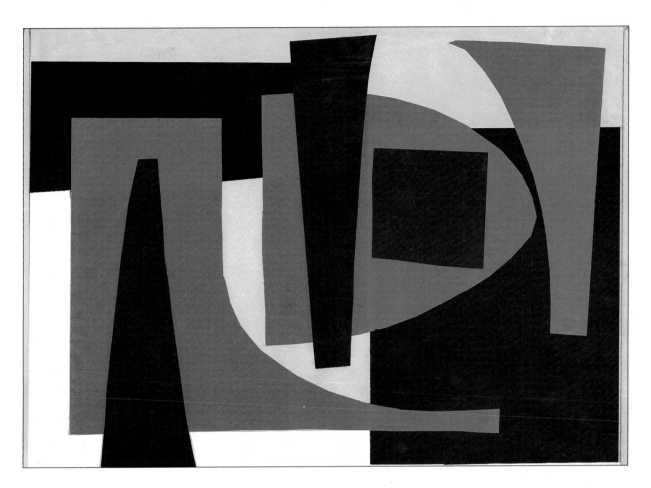

Abstract Collage △

Fig 4

PRACTICAL APPLICATION

When viewing any subject, try to observe the underlying shapes and tones in simple terms. For this practical application following the shape and tone exercise, I have used a watercolour sketch of Cotswold farm buildings. This is a very loose, exploratory study that demonstrates the basic abstract shapes and relative tones I was seeking.

Many of the abstract forms carefully observed in the previous exercise are present here: the subtle curves of the foreground grass areas, the relative dimensions and positions of roofs, windows and doors, and the simple, unadorned, basic tree shapes.

In drawing the grass areas I was, at the same time, defining the shape of the path, which could be regarded as a negative shape. Each part fits with the next, rather like a jigsaw.

It is often difficult when working on the spot to maintain a broad concept and sacrifice the details for an overall impression of shape and tone. For instance, in this farm subject the foreground was probably covered in wild flowers, weeds and tall grasses, and in order to eliminate the detail and see the general effect it is helpful to look through half-closed eyes.

Fig 1

Fig 1: This is a diagrammatic representation of the simple shapes I was seeking in the watercolour sketch of the farm at Taynton. The shapes have an underlying geometric pattern, the construction carefully calculated by eye, comparing vertical and horizontal lengths and how they relate.

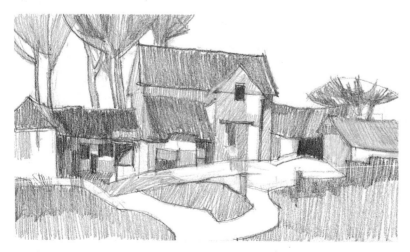

Fig 2

Fig 2: This diagram shows the subject in terms of simple areas of tone from very light to an extreme dark. I try to observe where the darkest and lightest areas are and then relate intermediate tones to them, judging where they are placed on the scale.

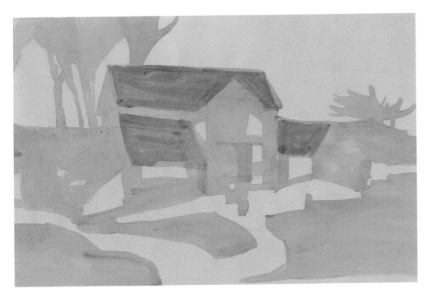

Fig 3: Here the preliminary tonal shapes are placed with a large brush and olive green watercolour. Buildings, trees and foreground are initially simplified as one tone. Darker tones are added gradually.

Fig 3

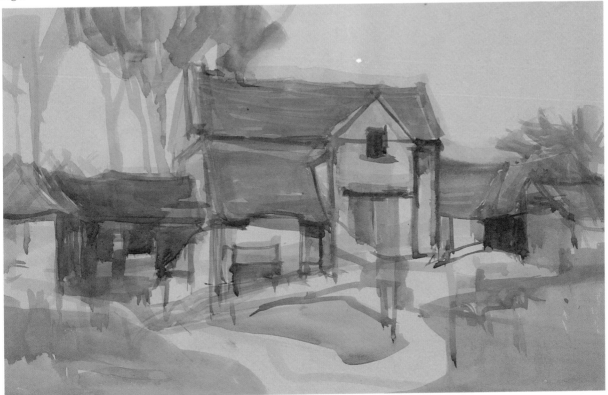

Farm at Taynton

The watercolour sketch of the farm was carried out quite quickly on a soft fawn-coloured pastel paper. I used mainly olive green and Payne's grey gradually to develop the arrangement of shape and tone and the general design of the subject. As a preliminary sketch it could be the basis for a pastel drawing, or be continued as a fuller, more detailed brush drawing.

Negative Shapes

Everyone sees things in their own way, and some-times it is challenging deliberately to draw a subject in an unaccustomed way. The exercises shown here deal with negative shapes; that is, the shapes that can be seen around and between objects. If these are accurately observed, the subject itself will become visible and be accurately represented. When we are drawing in our accustomed manner, a careful exami-nation of the negative shapes at the same time also tests and reinforces the precision of our observation.

Drawing the chair and stool was, for me, a satisfy-ing, if somewhat academic, exercise in observation and comparisons. The objects were placed against a plain, light background so that there was no con-fusion. A start was made on the outer surrounding shape, and then each negative space between the legs and bars of the chair and stool was studied in turn; in order to concentrate on these, the actual object was mentally ignored. There was continual questioning of each shape in relation to its neighbour, assessing what kind of rectangle or triangle, larger, smaller, acute-angled or on the same level, had been formed.

Negative shapes can be as interesting to draw as the actual forms themselves. The plants provided 'in between' shapes that were quite abstract, and the shapes of the surrounding area explained the plant as a simple mass of leaves.

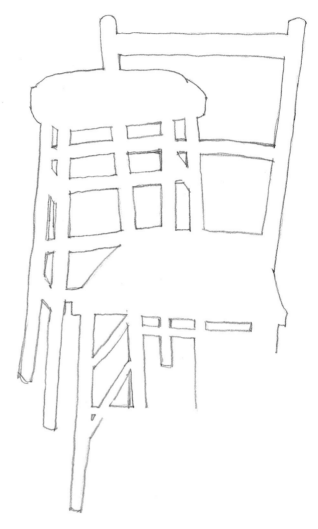

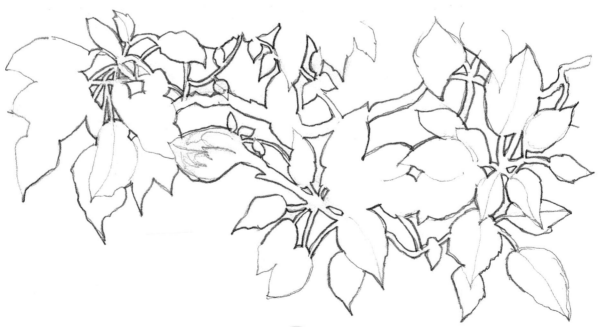

Drawing from Memory

Looking hard at subjects around us in order to commit them to memory makes us consciously more aware in our perception of actual form and colour. It is good to train our visual memory, and this will heighten perception. We see objects every day and take them for granted, but do we really *know* them?

This memory exercise proved to be a humbling experience that made me very aware of my shortcomings. I found it extremely difficult to commit all the information to memory even after looking at the objects very carefully. As my subject I chose three objects of varying complexity, and it rapidly became clear that the simplest shape was by far the easiest to memorise with reasonable accuracy.

Fig 1: The photograph shows the chosen still-life objects against a plain background.

Fig 2: After studying the objects as carefully as possible, I turned away and tried to describe with simple line work the essence of each object, starting with the plain vase. I had noted how narrow it was, and that the shoulder of the vase was sloping and the top rim was not straight. This proved to be fairly well remembered, whereas the teapot was only partly accurate. I had observed the relative positions of the handle and spout and judged the height of the spout compared with the lid, but had failed to notice the comparative size of the lid and surrounding rim.

The decorative coffee pot proved to be the most difficult object to memorise. I had some idea of the general characteristics of the pot and remembered that I could only see three legs, but my memory totally failed when I attempted to draw the handle. Such a total misconception of the shape at the top of the handle came as quite a surprise!

Fig 3: The drawing of the actual objects now proceeded with a keener sense of observation, questioning negative as well as positive shapes, and seeing the objects as a group.

This exercise certainly brought out the fact that we often think we see clearly until our vision is put to the test.

Fig 1

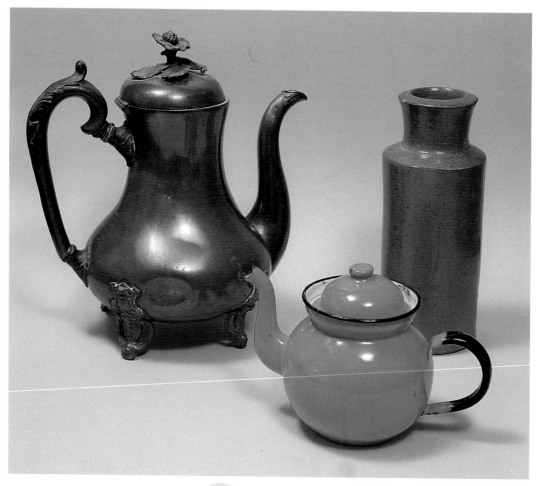

Fig 2

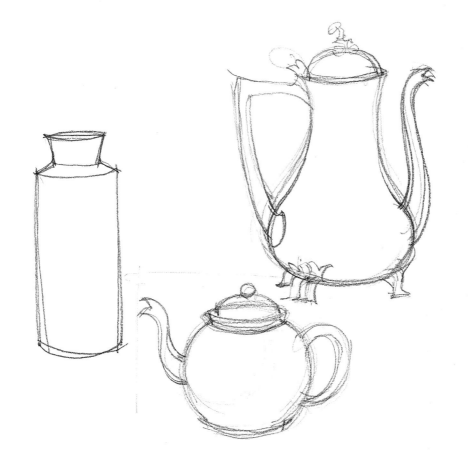

Fig 3

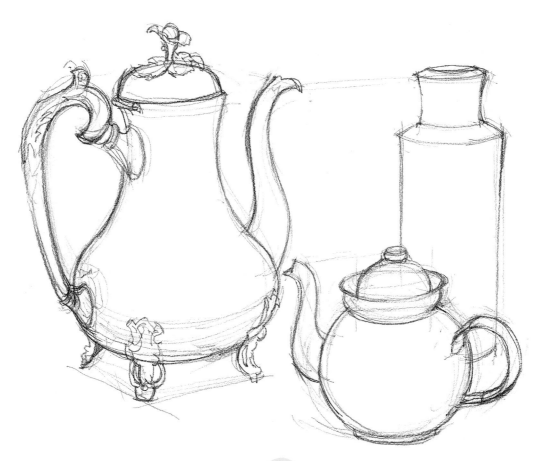

3
TECHNIQUES

Techniques can be many and varied, and those I suggest have been simplified into three categories: fine marks, broad marks and wet media techniques. These categories often overlap when media is combined, such as line and wash or acrylic and Conté pencil.

Fine Marks

PENCIL

In this section the techniques include a carefully detailed drawing with medium-hard pencils, a strong-toned free drawing with soft pencils, pencil combined with pen, and pencil and watercolour on white paper and on a textured toned paper. These are just a few examples of the possibilities of using pencils.

Adlestrop, Gloucestershire ▽
This strong black drawing of a Gloucestershire village was freely made with a 6B pencil. I used the side of the point to fill in trees and hedges, and kept the point well sharpened for fine lines. I knew before starting the drawing that I wanted to include the whole wide grouping of houses, so I tried to plan in my mind's eye where the centrefold of the sketch book would divide the drawing. There was a nice variation in the height of chimneys and widths of buildings, and as each one was observed I compared it quickly to the next. Groups of old buildings such as these, which have developed over the years in a higgledy-piggledy fashion, are always interesting to draw.

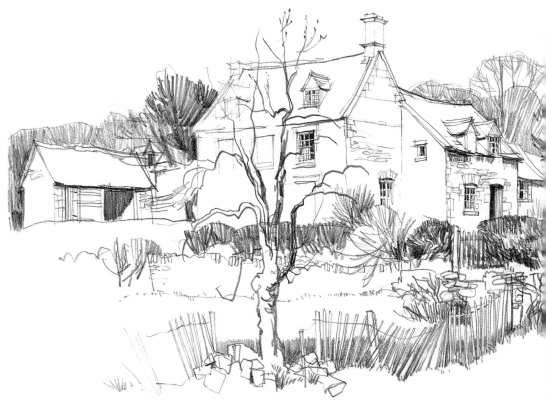

Northwick Arms Hotel

This is another period building, but approached this time in a more disciplined manner and with a careful regard to draughtsmanship. Exercises in observation and measuring by eye as discussed earlier were very much to the fore. I used harder pencils (HB and B) than for the Adlestrop sketch below, and kept them well sharpened. Many of the initial light construction lines can still be seen.

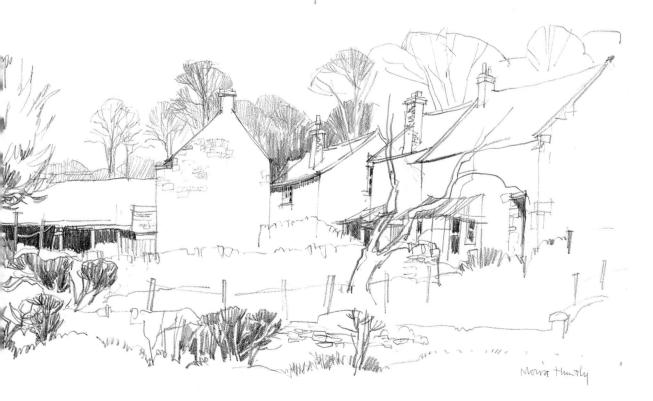

PENCIL AND WATERCOLOUR

Behind San Marco, Venice ▷

Venice backstreets and waterways are full of visual
interest and are exciting to draw. This started as a pencil
sketch and I wanted to hint at the colour as well as the
tone of the buildings against the sky, so I added
watercolour washes and then recorded some of the
contrasts of light stonework and washing on the lines
with opaque gouache. The aim was simply to add enough
colour notes to the pencil drawing to enable me to make
a future painting, and not necessarily to produce a
completed sketch.

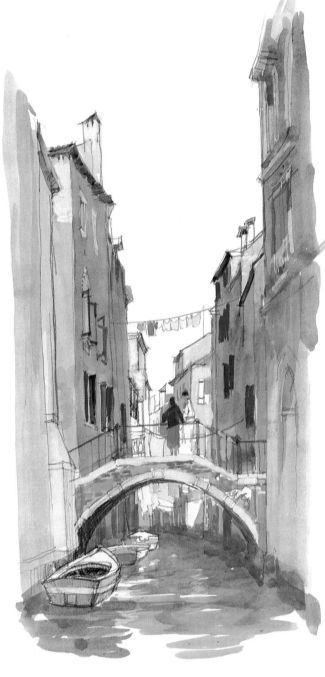

PENCIL AND INK

Near Strumble Head ▽

Here pencil has been used as tone on a pen-and-ink
sketch. I remember having to do this sketch in a hurry,
and realising that by changing to pencil I could quickly
record the tones for future reference. The resulting
combination of fine black pen line and the varied greys
of the pencil turned out to be quite pleasing.

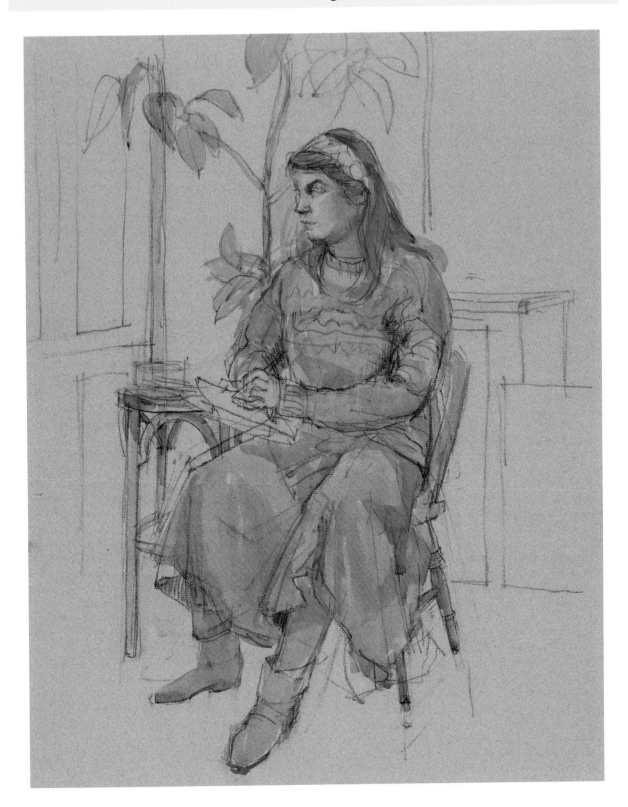

Figure by the Window

For this watercolour sketch I used a soft pencil on a mid-toned textured Ingres paper; the character of the line can be quite subtle, sometimes lost and found, according to the pressure used. The watercolour blends softly with the tone of the paper and combines well with the soft quality of the pencil line.

COLOURED PENCILS

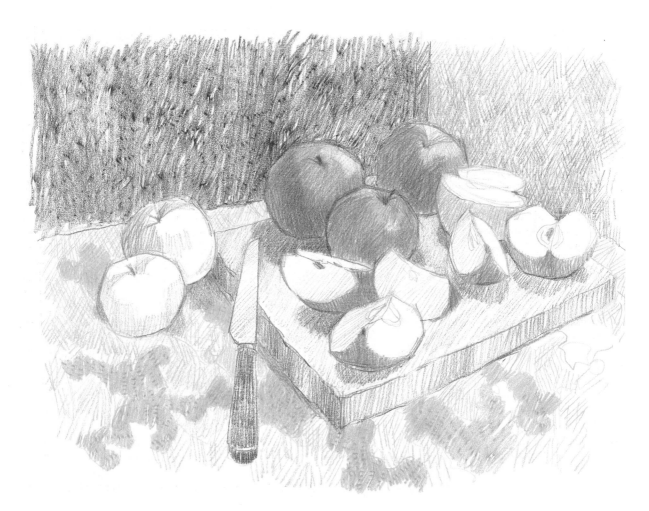

Coloured pencils have increased their reputation as a fine art medium since their usage by artists such as David Hockney, and the invention of water-soluble pencils has extended the range of techniques.

Amongst the characteristics of coloured pencils is their delicacy of touch and the subtlety of colour and tone that can be achieved by cross-hatching with different colours, giving variations of hue and texture. Flat areas of colour can be shaded evenly or modified by varying the pressure; dark colours can be overlaid with white to refine the tone, and erasers used to blend colour. Texture can also be achieved with pointillism, frottage or the choice of surface.

Water-soluble pencils can be used on dry paper and then blended with a brush and water, or worked onto a wet surface, where the line is immediately darker in tone and has a pleasing diffused quality. A mixture of soluble and non-soluble pencils works well together, and both can be used in conjunction with watercolour.

Cut Apples I
Several techniques were employed in this coloured-pencil drawing on heavy cartridge paper. The preliminary drawing was started with a warm orange pencil, reinforced with a green line and then the first moulding of the form was shaded with green, as can be seen on the unfinished apples to the left. A layer of orange was worked all over the apples, and then there was a gradual build-up of tone with successive layers of cross-hatching in brown and green, giving a subtle fusion of colour. A few highlights were picked out with a soft eraser.

Set against the soft, warm light effect of the group is a dark blue background, textured with a frottage technique. This was obtained by placing a woven rush table-mat beneath the paper, and then rubbing firmly across the surface with the pencil. The same technique was used for the dark orange areas of pattern on the cloth.

Fig 1: This example shows cross-hatching and frottage techniques with coloured pencils on cartridge paper.

Fig 2: Here water-soluble pencil techniques are demonstrated on HP watercolour paper. Above shows shading on dry paper, which is then worked into with water. Below shows drawing on damp paper – the line is thicker and diffused.

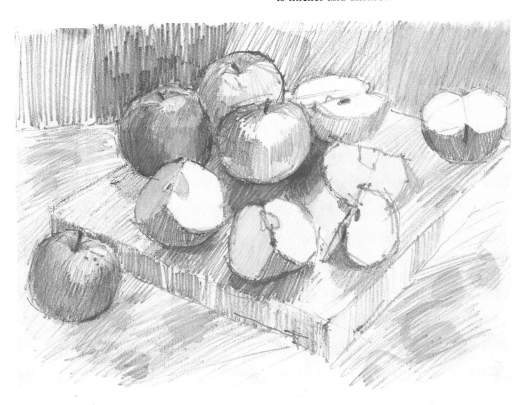

Cut Apples II

Water-soluble coloured pencils were used on hot-pressed (HP) watercolour paper, which was dampened with clean water. The outlines were drawn with burnt sienna and the line immediately became dark in tone and spread into the wash, giving a diffused, soft edge. Darker areas were superimposed with a dark green pencil before the paper dried. Delicate light-toned hatching was worked on dry paper.

The drawing was gradually developed with raw umber, and some areas were re-wetted selectively to achieve a stronger depth of tone. Subtle variations in the pattern on the cloth were created by dabbing some areas with water and then hatching across them with a dry pencil. The burnt sienna colour gains in strength as the pencil passes over the wet area, dragging some of the dissolved pigment with it.

CONTÉ PENCIL

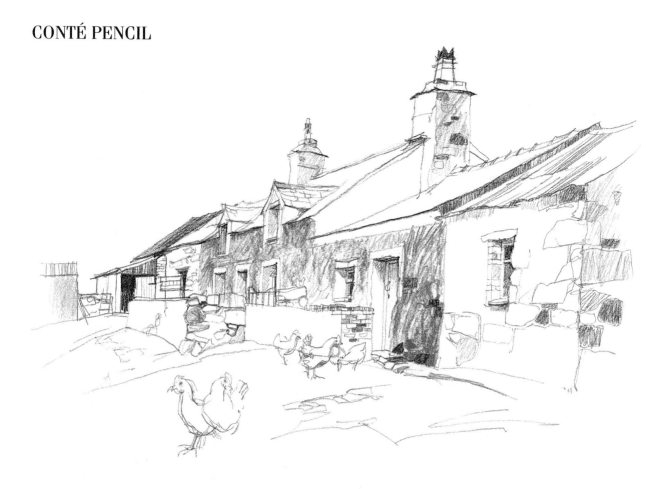

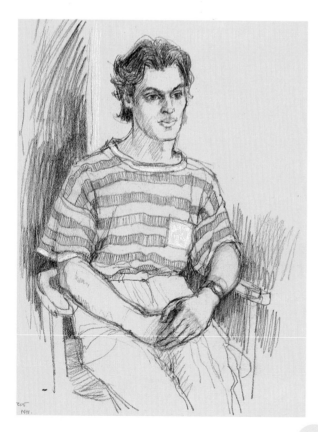

Farm near Dolbenmaen

This drawing consists of two tones on white paper. It started with a free drawing using a mixture of hard- and soft-quality black Conté pencils, giving a variety of line. I then changed to a grey pastel pencil for the textures on the face of the farmhouse, and to produce changes of tone on the stonework and tiles.

Andrew

This is a straightforward tonal drawing in hard black Conté pencil on a coloured ground of Canson pastel paper. Importance is given to the head by firm pressure on the Conté pencil, producing strong drawing. The arms are also made to come forward by using pressure. In contrast, the vertical hatching on the striped shirt is gentle and subtle and the spacing of the hatching is varied, becoming closer in the shadow areas and explaining the form of the body. Touches of white Conté pencil create a sense of colour.

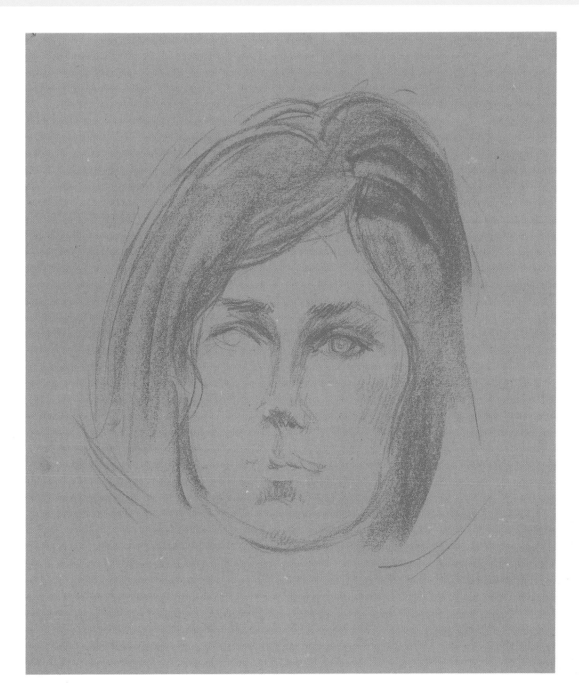

Young Woman

This sketch on grey-toned paper is in sanguine, which is an historically traditional reddish-brown drawing chalk, well suited to portraiture and figurework.

A very quick, unfinished sketch has a freshness sometimes lacking in a more carefully executed work. It can be difficult to know how far to take a drawing; in this case, the features are minimal at this stage, and yet almost sufficient. I may well decide that it is only necessary to finish the eye, and this would concentrate interest here, so that the mouth would be better left understated. The hair is more complete, using the side of the sanguine chalk to mass in the shape. It is often the overall impression of the head and hair that gives an instant recognition of the sitter, rather than the detail.

45

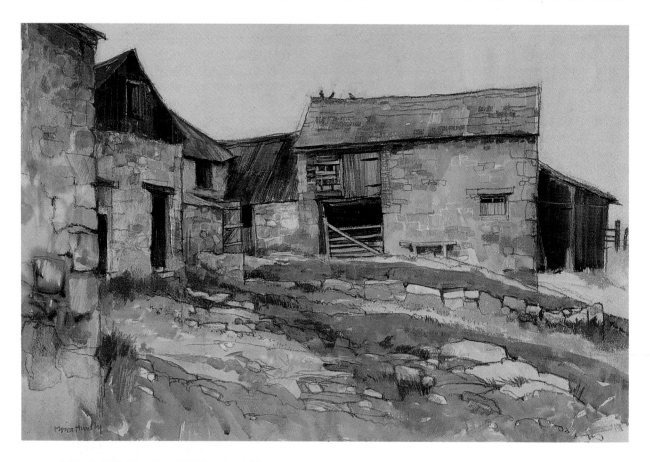

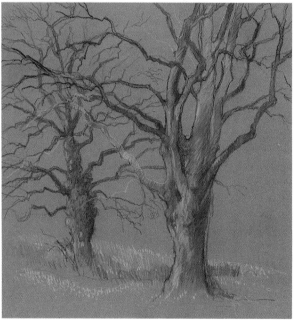

Farm near Chagford

This was a large, on-the-spot sketch combining broad colour washes with Conté and pastel pencils on a light-toned pastel paper. The buildings were drawn with sanguine pencil, changing to dark brown and black Conté pencil for dark-toned doors and windows. To begin with the line work was kept to simple outlines, and then the tone was added with watercolour. The colour was applied with a 50mm (2in) house painter's brush, the washes sinking quickly into the paper and blending with the soft quality of the Conté pencils. The warmth of the paper shows through and permeates the washes, giving a unity to the sketch. Finally, details were added with pastel pencils to register local colour, such as the small area of brick, white mortar and grey-and-brown stonework. It is wise to use fixative on Conté and pastel pencil drawings to prevent smudging, especially in a sketch book where one page can offset onto another.

Winter Trees

These winter trees were drawn on a dark-toned, charcoal-coloured pastel paper with pastel pencils. The first outlines were indicated with brown, and then parts of the nearest tree were brought forward by strengthening the line with dark grey pastel pencil. The build-up of pale grey and green on the trunks and ground gave a feeling of soft wintry light, the colours appearing very subtle on the tinted ground.

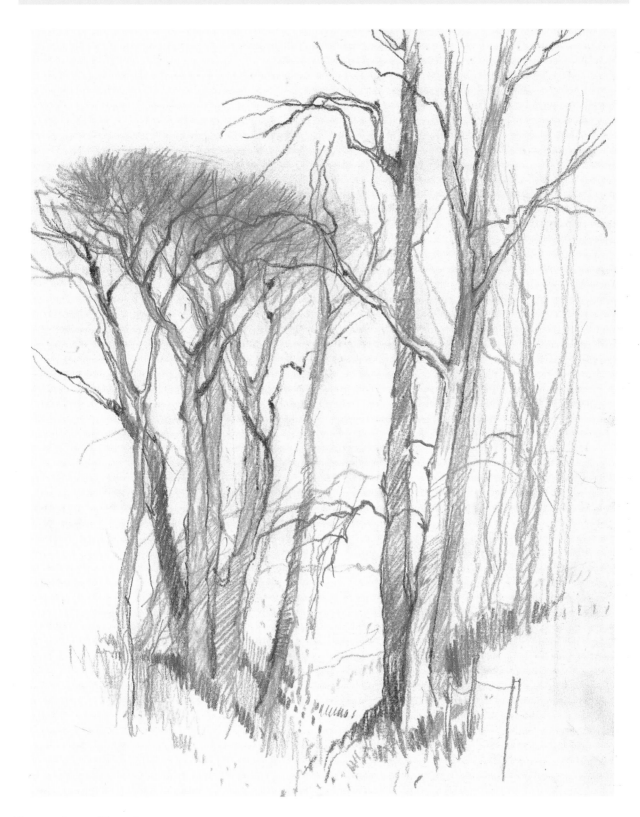

Trees above Broadway

This drawing was made on a day in early spring when the lighting was soft and misty and the warm haze of branches at the top of the trees was showing promise of new growth. Some of the pastel pencils I chose were the same as those used on the winter tree study, but their effect on white paper was more light and airy. Grey and light green were used to draw the outlines of the trees, changing to brown for some of the darker branches. Some of the trunks in dappled light were shaded with green and grey and worked over in places with raw sienna. A touch of burnt sienna was introduced on the finest top branches.

PEN AND INK

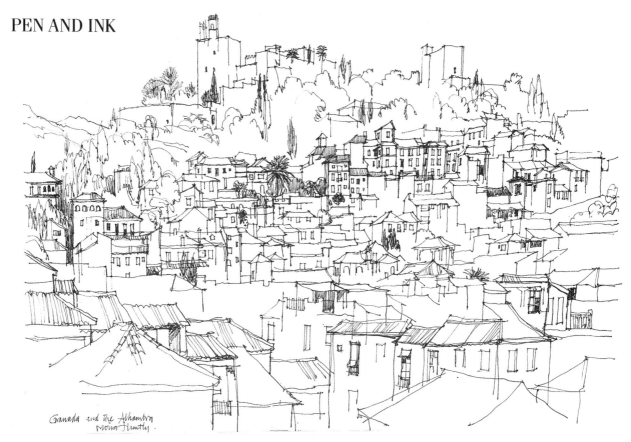

Granada and the Alhambra
Moira Huntly.

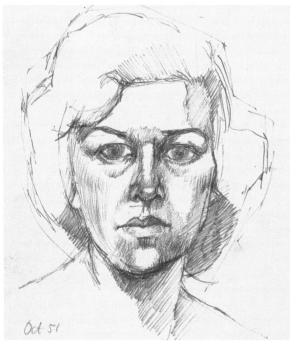

Oct 51

Head

The drawing above was made many years ago when I was a student. It was a spontaneous 'end of the day' drawing with whatever tool was to hand, in this case a fountain pen. The blue ink flow was manipulated to give broken light tones by dragging the nib quickly across the paper.

Granada and the Alhambra △

This wonderful Spanish city provides an aesthetic feast for the eye, and subjects abound around every corner. The whole panorama seen from the hotel balcony was a challenge, and the first judgement I made was on the starting point. I decided to start with the Alhambra palace as the highest-placed building in the group, and once this was established all other buildings were related to it vertically and a check made on comparative widths. No building was drawn in isolation; the position of each one was observed in relation to the next on all levels. A quick reference glance is all that is needed as the drawing progresses. The light-fast fibre-tip pen was an ideal drawing tool, allowing speed and clarity for such a complicated subject.

Pen and ink has been used by artists for hundreds of years and is a medium that gives plenty of scope for individual expression. A sensitive line can be drawn with a dip pen – the flexibility of the nib will respond to pressure and thick and thin lines can be achieved. Tone is usually created by hatching and cross-hatching.

Pen and ink is a direct medium that requires some confidence, and this will be gained with practice, but if you feel fearless then draw freely with a fine nib and then go over and strengthen the drawing where

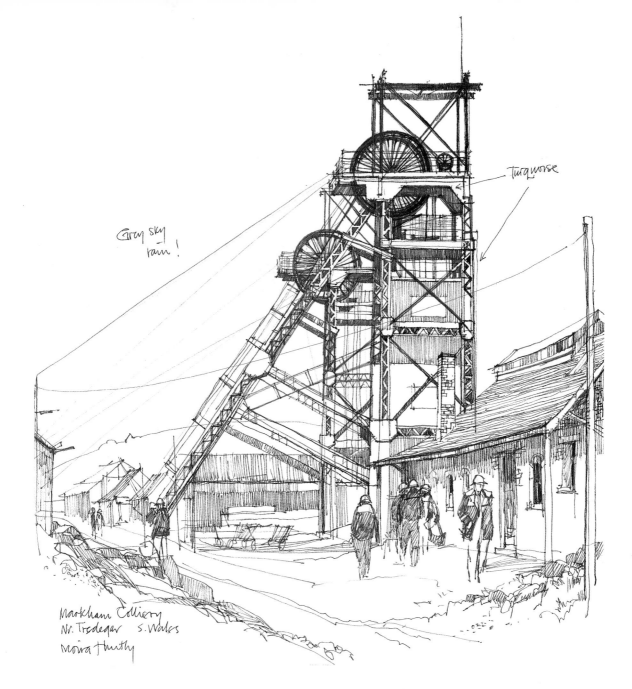

Grey sky —
rain!

Turquoise

Markham Colliery
Nr. Tredegar S. Wales
Moira Huntly

required with a thicker nib. This was the technique used for the drawing of the coalmine above, but instead of a thicker nib, the line was reinforced with a felt pen. However, if a subject is extremely complicated, it is wise to start with a few thin pencil guidelines.

Drawing pens, such as reservoir or fibre tips, are very useful for sketching. The ink is waterproof and the drawing points come in different sizes, but the line is more uniform and tends to be mechanical.

Fountain pens and biros are also useful for quick, spur of the moment sketch-book studies. The ink may not be waterproof or permanent, but is quite adequate for working drawings. The woman's head opposite was drawn with a fountain pen, using hatching to give direction to the planes of the face, and in the process creating areas of light.

Markham Colliery

This coalmine was a complicated subject, and I looked hard at the structure before beginning. The drawing started with fine pen lines to register the basic proportions, comparing height to the width of each tower and to the diameter of the winding wheels. Apart from the miners, the whole subject is made up of squares, rectangles and triangles, and many of these motifs are repeated in the details. Observation of negative shapes, as for instance the sky shapes seen through the top of the tower, serve as a check-up on perspective and dimensions in general.

A hatching technique was used for mid-tones, and a felt pen for the darkest tones and to strengthen some of the line work. This was a working sketch to be interpreted as a painting in the studio and the notes were a reminder of what attracted me on the day.

PEN AND WHITE INK

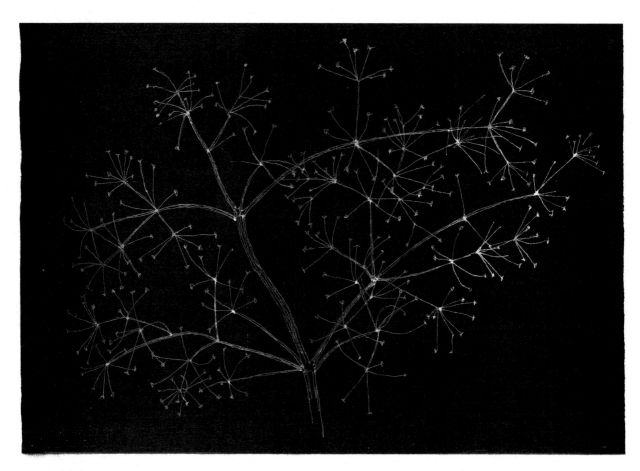

Canalside Plant

I was out drawing in Birmingham on a winter's morning and noticed this plant growing by the side of the canal path. The dried head was very fragile but survived the journey to the studio, where it has been kept for several years. The delicate tracery and complexity of the tiny branches is one of nature's marvels, and in order to capture this, I decided to draw with white ink on dark paper. White ink is at its most effective on black paper and is a perfect medium for fine detail.

In order to see the plant clearly, I placed it in front of a piece of white paper pinned to a board. Even so, it was difficult to follow the growth of each short-stalked cluster of minute branches. Each one fans out from a central point at varying angles, some long, some short and some criss-crossing others. It is easy to get 'lost' whilst drawing such an intricate pattern of spikelets, so it was necessary to indicate the main branches first and note the direction of the secondary branches, so that the general characteristic of the plant form is observed.

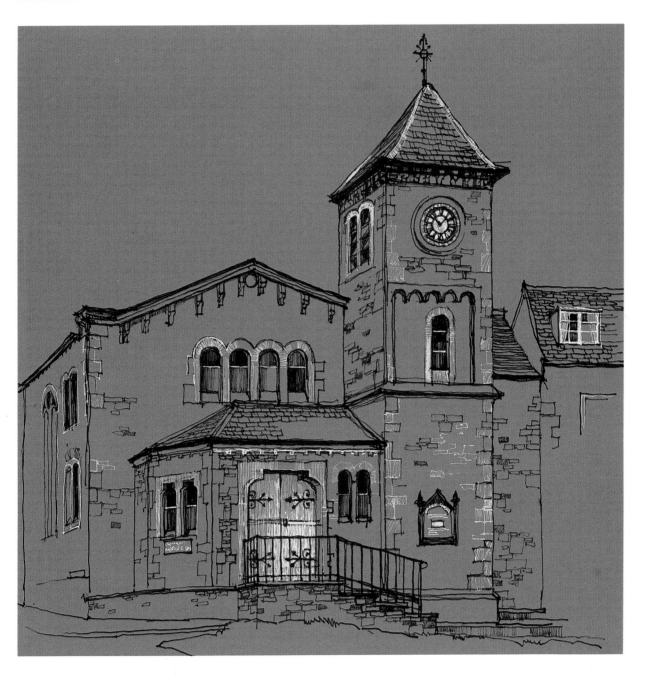

Church at Stow-on-the-Wold △

A sketch pad of tinted Ingres paper was used for this drawing combining black and white ink. The light brown paper was chosen as a colour appropriate to the Cotswold stone of the building. The mixture of architectural periods, decorative elements and different-shaped windows made it a visually interesting building to draw.

Before making a pen mark, I tried to visualise the overall shape of the subject and how it would fit on the paper, and I then started by placing the tower. To ensure that my first line was vertical, I used the side of my sketch pad as a guide, holding the pen firmly and running my little finger along the edge of the pad as I brought the line down. If the hand is kept rigid, the pen line should be running down parallel to the edge of the pad.

Having established the first vertical line, the other sides of the tower can be related, at the same time judging the height of the tower compared to the width, and so on.

Thin black pen lines were used to begin with and then reinforced where a darker line was required. Darkening the windows and adding stonework immediately gave the building solidarity. White ink was used last, picking out light stonework, white paint and the clock, and providing a nice contrast to the colour of the paper.

LINE AND WASH

centre fold of
sketch book

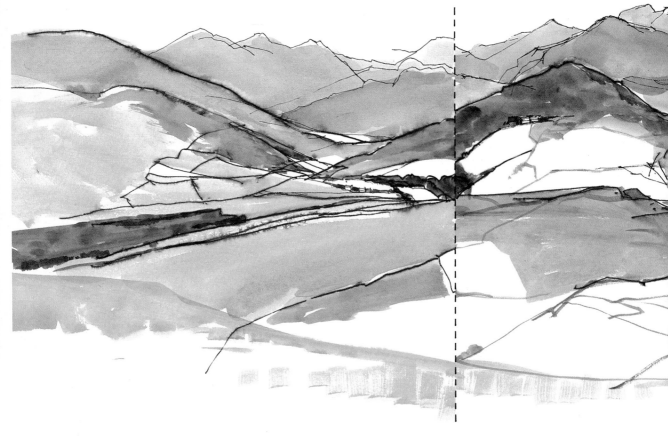

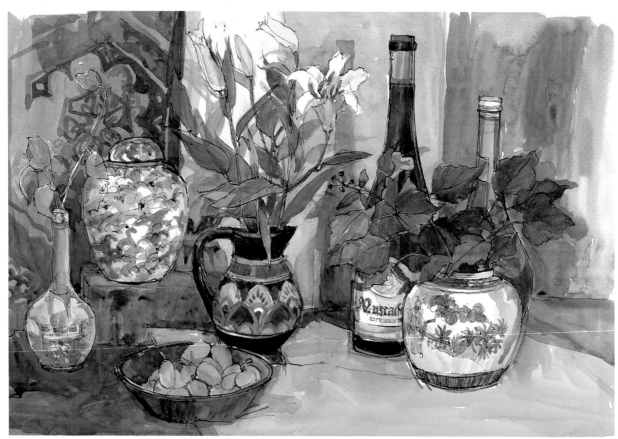

Cumbria

MgH

Still Life with Portuguese Jug ◁

In this line and wash drawing the colour washes are the dominant factor and the line work takes a lower profile. The work was begun with a very free brush drawing using Hooker's green watercolour, and then washes of green and cadmium red were applied. Pen-and-ink drawing was superimposed with a thin, rather spidery line, keeping to an open outline which appears to have just wandered over the paper. In this way of working the ink line integrates with the colour work, the line moving through the work 'finding and losing' itself, and never interfering with the emphasis on colour. A brush was used to complete the colour work.

───────────

Line and wash techniques have been used throughout the centuries to make drawings that are complete in themselves, or as a prelude to painting. Approaches to the technique can vary: a detailed pen drawing might have washes added to record the colours, or washes added to reinforce the line work with tone. This could be in monochrome or limited colour, using mixes of sepia, and introducing black and ultramarine blue for the distance. In these examples the wash is used to support the line.

Cumbria △

This sketch was made on the spot to record the panorama of mountains from which eventually to make a painting. The vastness of the scene prompted me to use a large A2 sketch book despite the strong breeze.

For such a quick gathering of material, line is very suitable, and more than one thickness of pen mark was employed. A fine line waterproof fibre-tip pen was used for the distant hills and details, and a thicker felt-tip pen for nearer mountain and trees. It should be pointed out, however, that felt-tip pens are neither light fast nor waterproof, but are very suitable for free-flowing personal sketch-book drawings.

Pale watercolour washes were applied after the drawing was complete and some of the felt-pen work immediately spread into the wash, creating a soft blurred line. The washes were added to give substance to the drawing and some idea of colour recession and the pattern of fields. Subconsciously perhaps, some selection and interpretation has been made on the sketch by the distribution of washes that has left some fields uncoloured, so that the eye is led from the wide foreground through the valley and on into the picture.

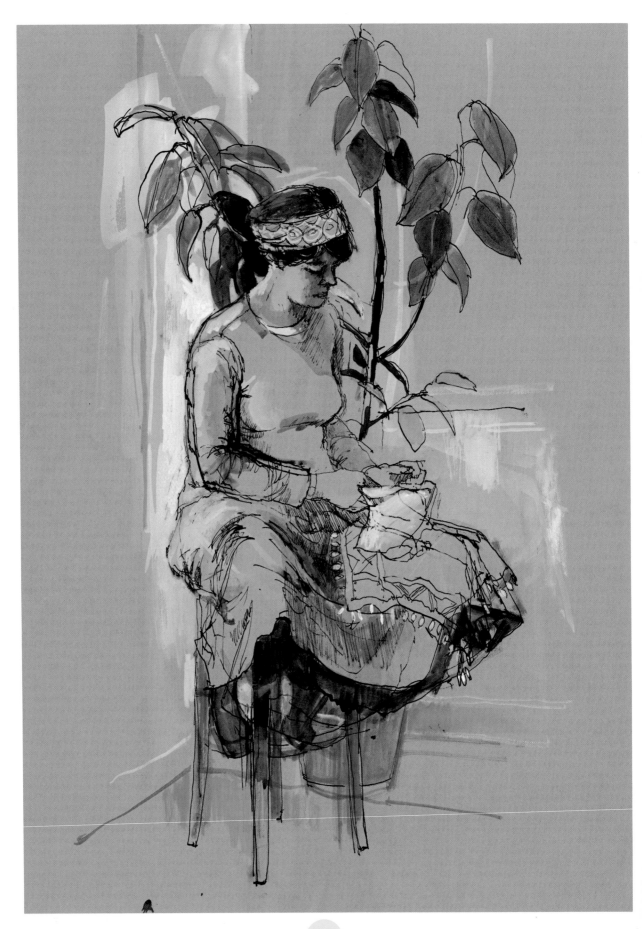

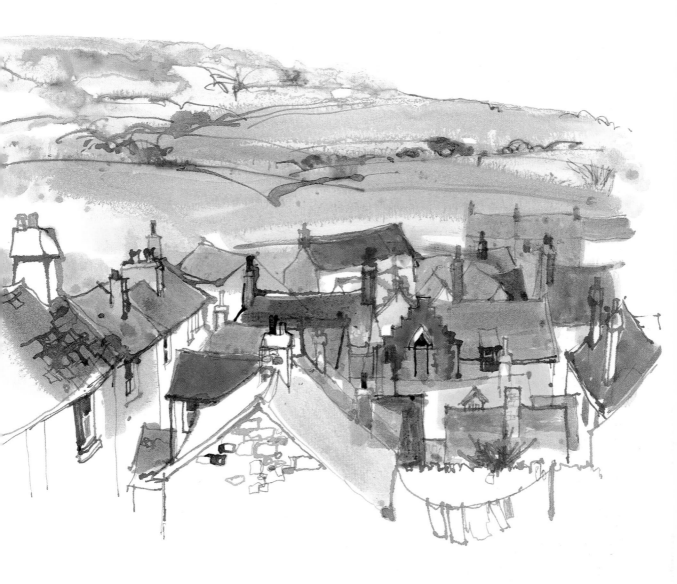

Cecilia Sewing ◁

This is a study in black, white and grey tones on pink-coloured Ingres paper. I started the drawing with a dip pen and black Indian ink, the constant movements of the figure making it difficult for me to draw the arm, and so several exploratory attempts are evident. I did not try to tidy these up – they all become part of the drawing. Much of the line work is made freely and again in an explorative fashion, and this is particularly apparent on the skirt. The washes are of diluted ink of various strengths to give different grey tones, and the back lighting from the window and pattern details are painted with white gouache.

———————————

Alternatively, the drawing might start with freely applied washes which are later pulled together with superimposed line work. Here the wash is independent of the line. Usually, we make a choice at the outset as to whether the emphasis is to be with the line or the wash, but that choice is purely personal.

Rooftops △

This drawing was made on 90lb (185gsm) watercolour paper using four coloured inks. The transparency and brilliance of coloured inks can produce exciting results, but it should be remembered that these inks can be fugitive.

The paper was wetted with clean water, and thin washes of yellow green, indigo and crimson ink were freely applied, their strength being instantly diluted and dispersed by the water. Line work was superimposed with olive green, crimson and indigo without keeping rigidly to the edges of the washes although, perhaps surprisingly, this did have the effect of pulling the spontaneously applied initial colour together.

Some of the pen work was drawn over areas of paper that were still damp and the line flared unexpectedly, giving an interesting effect. More ink was then brushed on, the overlapping colours creating subtle secondary colours and increasing the dark tones.

Broad Marks

In this section the techniques include drawing and erasing with charcoal, watercolour under charcoal, rubbing soft pastel into the paper, and working soft pastel over watercolour. The broadest mark techniques combine candle wax with watercolour, oil pastel with turpentine and oil pastel over acrylic.

The Studio ▷

This drawing of a corner of the studio was made late one afternoon in midwinter, when the dark sky outside the window became an important focus in the drawing, balanced by the dark jugs. There was so much of interest in the studio that I felt it had to be a large drawing; I used a whole sheet of cartridge paper 75 x 56cm (30 x 22in) and a thin and a thick stick of willow charcoal. A tonal drawing such as this can be a preliminary workout for a painting, or stand as a finished image in its own right.

CHARCOAL

Charcoal is an ideal medium for producing a wide range of tones, from black to the palest grey. It is also a quick medium to draw with, the softness of the charcoal stick gliding easily over the paper, and when used on its side large areas of tone can be filled at speed. Unwanted lines can be eliminated and alterations made by wafting off the charcoal with a clean rag or by using a putty eraser. It is advisable to spray charcoal drawings with fixative, otherwise they may smudge or be wiped off.

Cotswold Landscape △

This was a rapid sketch done on the spot on light-toned Ingres paper. The charcoal registers the various tones of the trees and bushes, and by changing the pressure of the charcoal on the paper different degrees of density are achieved, from very pale to very dark. Some of the charcoal has been lifted off with a putty eraser to obtain highlights.

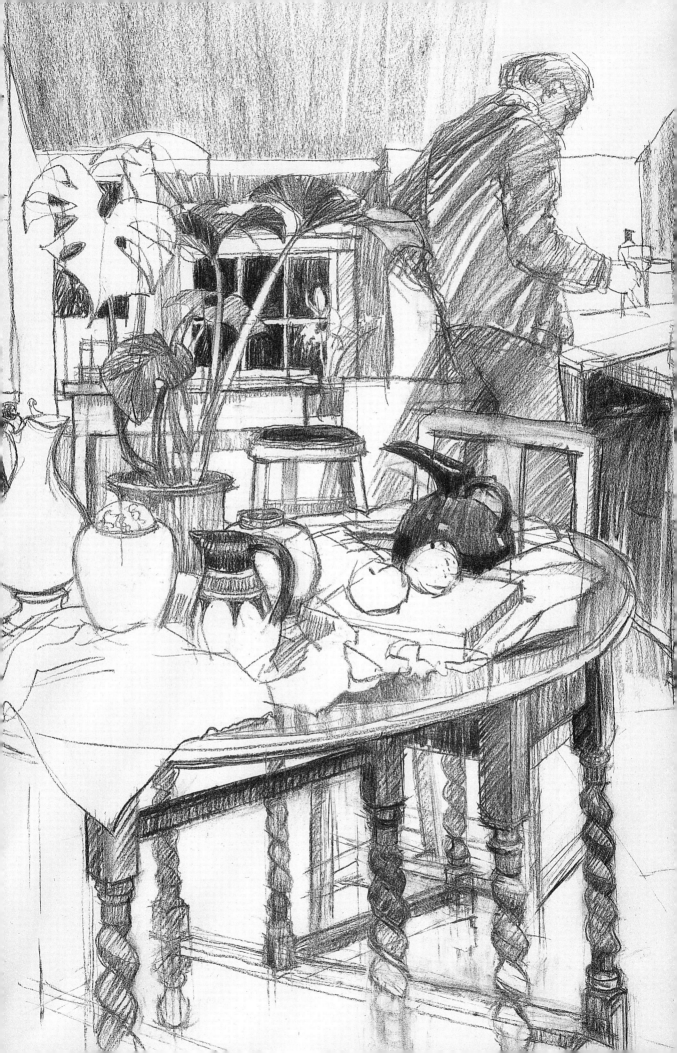

DEMONSTRATION

CHARCOAL OVER WATERCOLOUR

Mountain Stream

Exciting results can be achieved by using charcoal over washes of watercolour. In this demonstration, simple flat colour washes are covered with a layer of charcoal. Charcoal is not totally opaque and the washes can be seen through it, so the procedure is not as drastic as it sounds. Selective drawing into the charcoal with a soft eraser reveals the washes beneath, creating a feeling of light on the landscape. Soft tones can be achieved by rubbing the charcoal gently with a finger or tissue. Finally the image can be strengthened and details added by drawing with the charcoal tip or a charcoal pencil.

STAGE 1

Loose washes of raw sienna, indigo, burnt umber and a small amount of alizarin crimson were brushed on to cartridge paper. A large or very thin piece of paper would need stretching beforehand. The washes are simple shapes with flat areas of colour and no detail. The watercolour was allowed to dry completely before applying charcoal at the next stage.

STAGE 2

The watercolour was covered all over with a layer of charcoal, which seems an alarming thing to do, but just enough of the colour washes are discernible through the charcoal to keep control of the image. The charcoal provides a strong tonal base to work on and to create chiaroscuro effects of light and dark.

STAGE 3

This is an interesting stage, where a putty eraser has been used as a drawing tool. Drawing into the charcoal with the eraser reveals the colour beneath and picks out areas of light on the landscape. The eraser becomes dirty very quickly during this process and requires constant cleaning on a scrap of paper so that the charcoal is not re-deposited on the image.

Decisions have to be made as to which parts of the original wash to expose and which parts to leave covered. First decisions need not, however, be final. If an area is not satisfactory, a fresh layer of charcoal can be applied and work with the eraser can begin again. Charcoal can also be blended with the fingers: the soft tone of the sky was achieved by this method, and then the edge of the eraser was dragged across to

create light streaks. Some of the rock faces were exposed with the eraser, and on part of the ground textural effects were obtained by dabbing and stippling with the corner of the eraser. Dark tones were strengthened, and details of rocks and grasses added by drawing with the charcoal tip.

Charcoal smudges very easily, so it is wise to spray with fixative once the drawing is complete.

DEMONSTRATION

SOFT PASTEL

White Chrysanthemums

This technique uses soft pastel to make broad marks. Working on a mid-toned paper, the dark tones were established first, and then the drawing was fixed.

This tonal drawing quickly creates an overall impression of the subject, and the application of fixative keeps subsequent colour work clean.

STAGE 1

The work began with very dark green pastel on smoke-grey paper. The pastel was used on its side to mass in the background, leaving the paper untouched in the area representing the flowers. In

order to see the simple overall shapes of the light flowers against the background, it is helpful if the group is looked at through half-closed eyes, a process which eliminates the detail. The background colour was partly rubbed with the finger to get rid of the grain of the paper, which can be a distraction within a dark area. At this stage, a strong impression of light and shade is quickly apparent. The drawing was then sprayed with fixative.

STAGE 2

Middle tones on the flower heads and cloth were massed in, occasionally overlapping the dark background. The light falling on to the upturned petals was laid on thickly with the tip of the pastel so that granules of pastel lying on the surface of the paper reflect light and create a strong chiaroscuro and feeling of sparkling light. Lastly, details were added such as the pattern on the ginger jar.

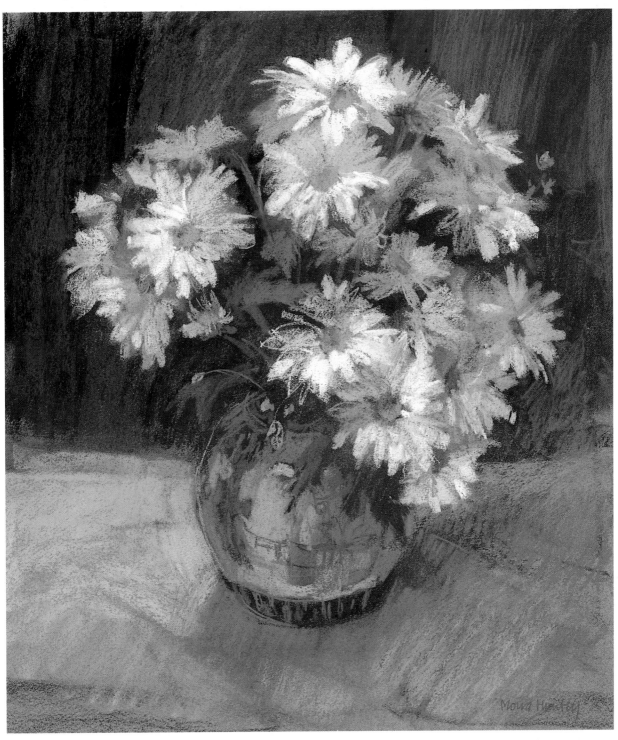

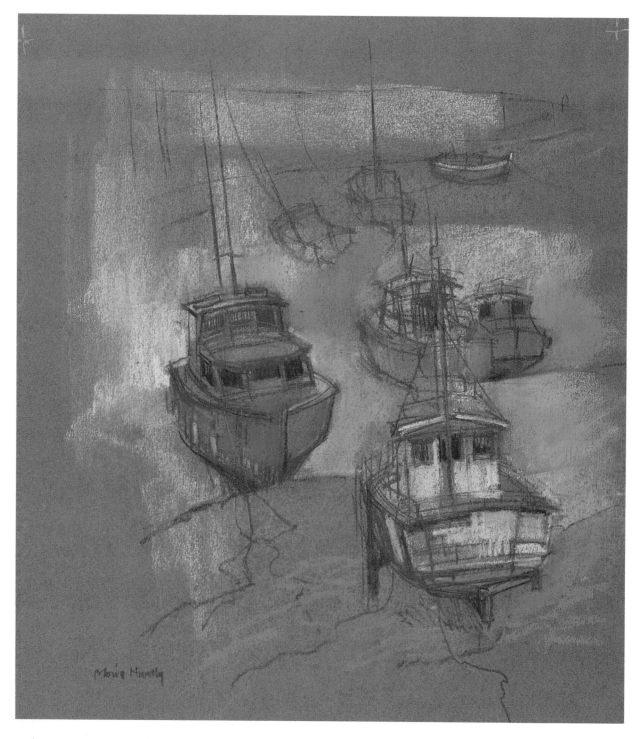

Boats at Low Water

Here pastel is worked over a dark-toned strong-coloured paper which greatly influences the effect of the drawing. Subsequent colour can be vibrant against such a background. The main technique I have used is to rub soft pastel into parts of the paper, filling the grain and creating an area of softly blended colour on which to draw. The rubbing can be done with the fingers, a torchon or a rag. A square-ended, harder type of pastel was used for the drawing, enabling a sharp, precise line to be achieved.

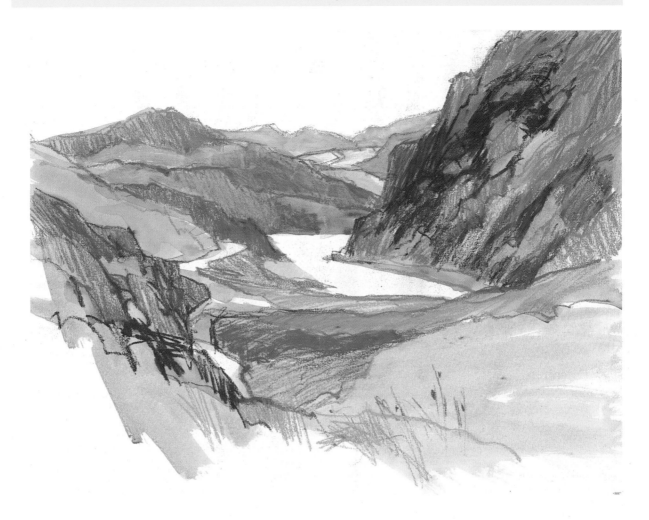

Sutherland

The pastel drawings on pages 61 and 62 were made on coloured paper. This drawing was made on white pastel paper, over which I applied washes of watercolour. The pastel was then applied over these washes. An advantage of this method is that a varied coloured background can be obtained instead of the one self-colour of paper. In this example I used Payne's grey watercolour mixed with a little cadmium red for areas to be occupied by the mountains, and raw sienna in the foreground. Then I started to apply strokes of pastel into the still-wet paint. The effect of this is for the pastel to tend to mix with the paint, becoming almost paste-like and producing an interesting paint surface and increased intensity to the pastel line work. Dark tones tend to soften as the washes dry and allowance must be made for this, judging when to apply the pastel. The process is most effective when the washes are not entirely covered with pastel, so that they show through the pastel strokes to give interesting effects.

Saundersfoot Harbour (overleaf)

The work overleaf was once again carried out using one of my favourite combinations of media, involving an underpainting in watercolour on a toned paper with pastel drawn on top. The watercolour sinks into the pastel paper without clogging its texture, thus enabling the subsequent pastel drawing to adhere to the tooth. For the preliminary massing in of the composition I used burnt umber and Payne's grey watercolour applied with a 40mm (1½in) house painter's brush. My primary aim with the watercolour was to establish the pattern of darks: the two large areas of water are linked by two dark-toned figures, and smaller dark shapes of rooftops, windows, doors and trees weave in and out of the light buildings. The drawing was superimposed with pastel pencils and with the tip of a pastel stick.

A colour emphasis was based on pale yellow and its complementary colour, pale purple. This was expanded either side of the colour circle to include warm orange-yellows and brown-yellows in opposition to blues and blue-greys. Then there was a gradual build-up of close harmonies of yellows and purple-greys, particularly in the light areas, allowing some of the mid-toned grey paper to show through. Touches of more intense colour were added, and these make a considerable impact interspersed amongst the larger areas of subtle colour.

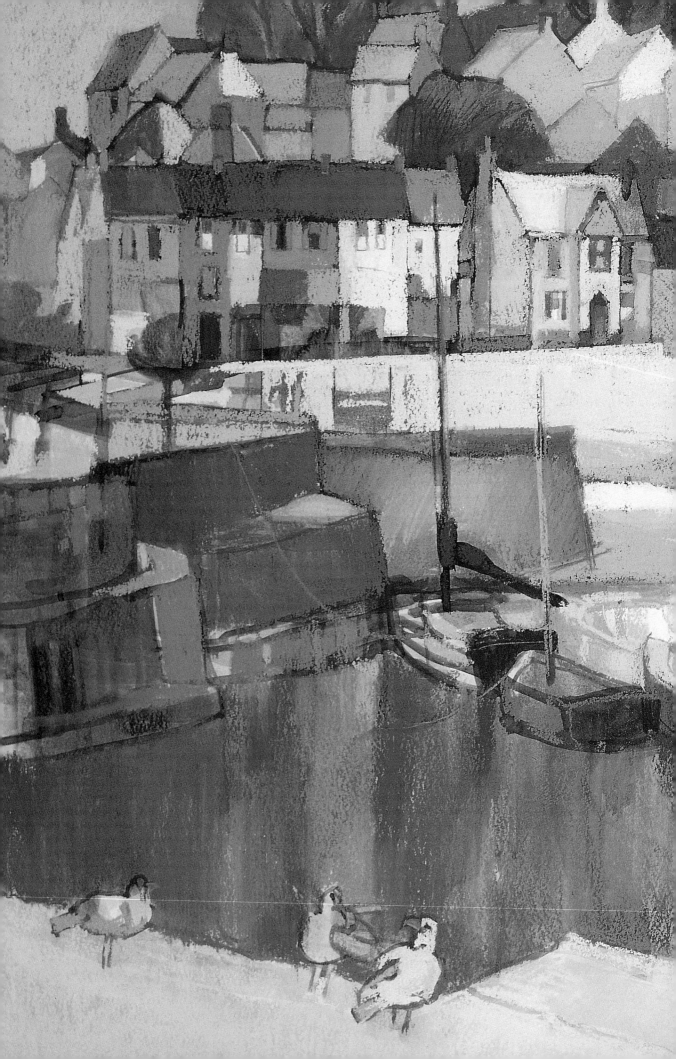

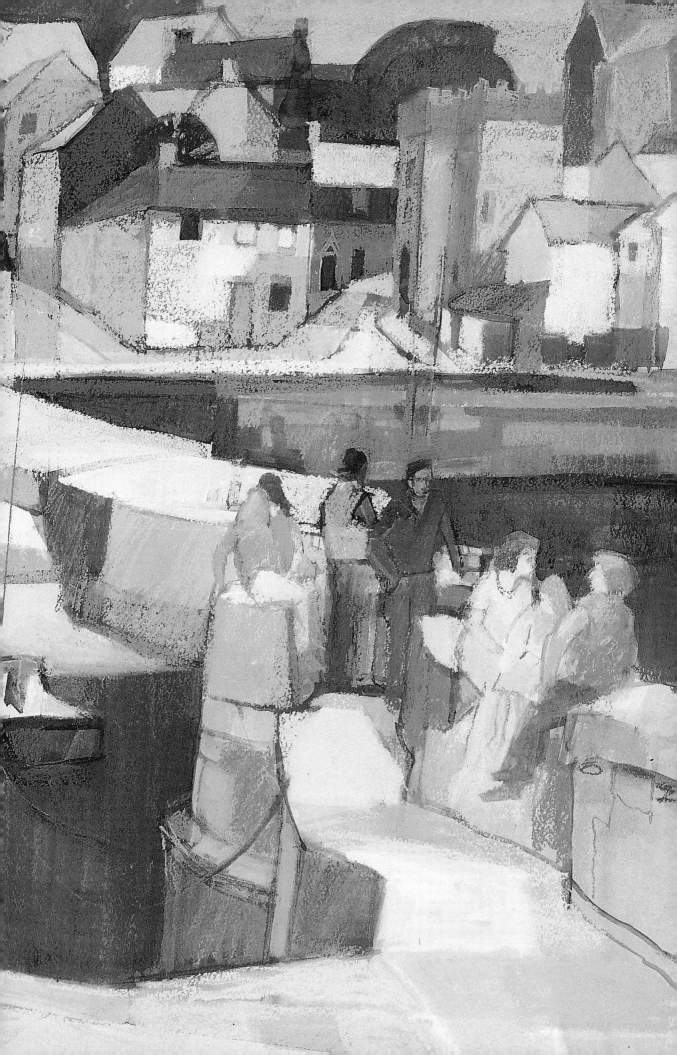

WAX

Washes of watercolour over a layer of wax can form the basis for interesting and exciting effects. The process exploits the fact that wax repels the wash and creates globules of colour, giving a mottled, textured finish to the image. Two very simple techniques are illustrated here, one using washes of dilute ink over candle wax and one using watercolour, again over candlewax.

Rocky Stream ▽

This started with a faint pencil outline on fairly smooth paper. I then rubbed candle wax over areas where I wanted highlights on the rocks. I washed very diluted Indian ink over the paper and added some line work in places with a pen and Indian ink. Here and there the line has flared into the damp washes. When the washes were dry I applied more wax on some of the lightly washed areas, and then applied a darker ink wash over them. Finally, I applied more wax and very dark ink washes. At each stage, the wax repels the ink wash to create mottled surfaces.

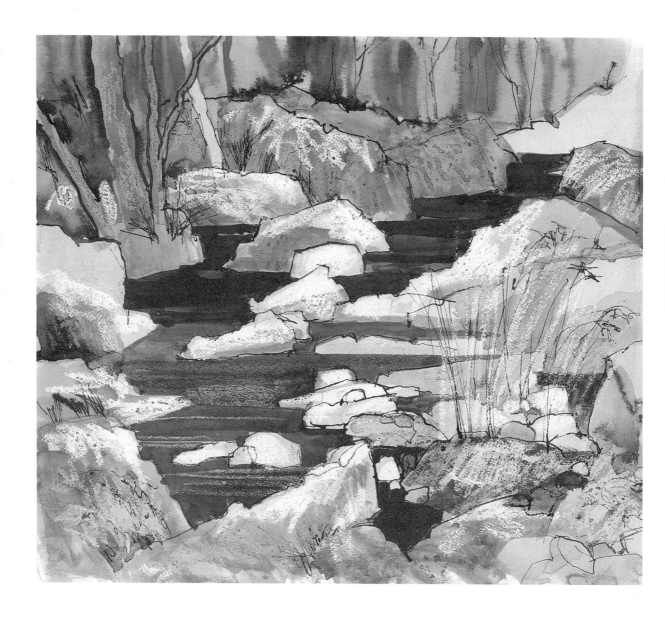

Pembrokeshire Coast △

The coastal drawing was made with black Conté pencil and then fixed. Textures are quickly created with candle wax, and I scribbled a small amount over parts of the rock surfaces and water, and then gave the whole image a wash of raw sienna watercolour. The waxed areas immediately appeared as white paper, only a little colour adhering to the wax and giving a mottled effect. When the wash was dry I worked some candle wax over areas of raw sienna, and then added a wash of Antwerp blue. The second application of wax now revealed the first colour wash, and the first application of wax remained as white paper. I repeated this process several times with further washes of olive green and burnt umber on selected parts of the drawing.

OIL PASTEL

Oil pastel is less fragile than soft pastel, and is very suitable for broad work without fine detail, although because of its waxy nature it can be sharpened with a knife. Colour can be blended with the finger or with a brush moistened with turpentine; extra turpentine will produce wash effects. It is also possible to layer oil pastel and then scratch through the top layer to reveal those beneath.

Heavy cartridge paper, well-sized heavy watercolour paper, oil paper or canvas boards make suitable supports, particularly when working with turpentine – the sizing will prevent oil and turpentine stains from soaking through the support. For creative drawing techniques, oil pastel can be used in conjunction with other media, such as Indian ink or watercolour, where the properties of oil repelling a wet medium can be exploited. Oil pastel can also be worked over watercolour or acrylic washes, acrylic paint serving as a primer.

Oil pastel does not require fixing, but should be left to dry out for a few days. Work can be stored flat between sheets of greaseproof paper, and when completed is usually glazed in the same way as soft pastel.

Near Pen-y-ghent, Yorkshire

This Yorkshire landscape drawing was made on smooth cartridge paper in my sketch book. Oil pastel is a good medium for making quick colour sketches, particularly as reference for studio painting. First perceptions can be recorded rapidly without necessarily producing a finished drawing, just gathering enough information about shape and colour. Very often a drawing intended as a basis for painting is informative only to the artist, rather like private notes.

Oil pastel is sticky and will offset on to the opposite page in a sketch book, so it is advisable to leave a page blank.

DEMONSTRATION

OIL PASTEL

Raggra, Caithness

This sketch was made with oil pastel on a heavy,
Rough surface watercolour paper.

STAGE 1

I drew a simple outline of the buildings and background with sepia oil pastel and then added areas of colour. The soft, waxy texture of the pastel adheres to the surface grain of the paper to produce a loose, free sketch, broad in handling – no detail is possible with this medium.

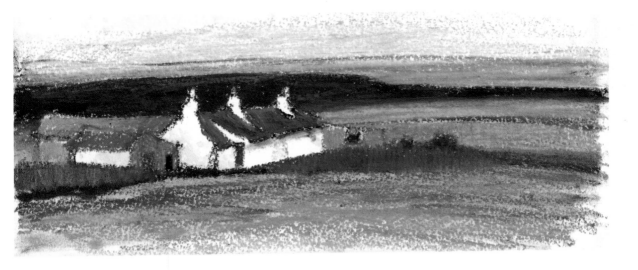

STAGE 2

I blended the colour with a small oil brush dampened with turpentine. Then, by adding more turpentine, a wash effect was obtained in places so that the colour filled the grain of the paper. This is noticeable on the background hill, the strip of green and on the roofs of the buildings.

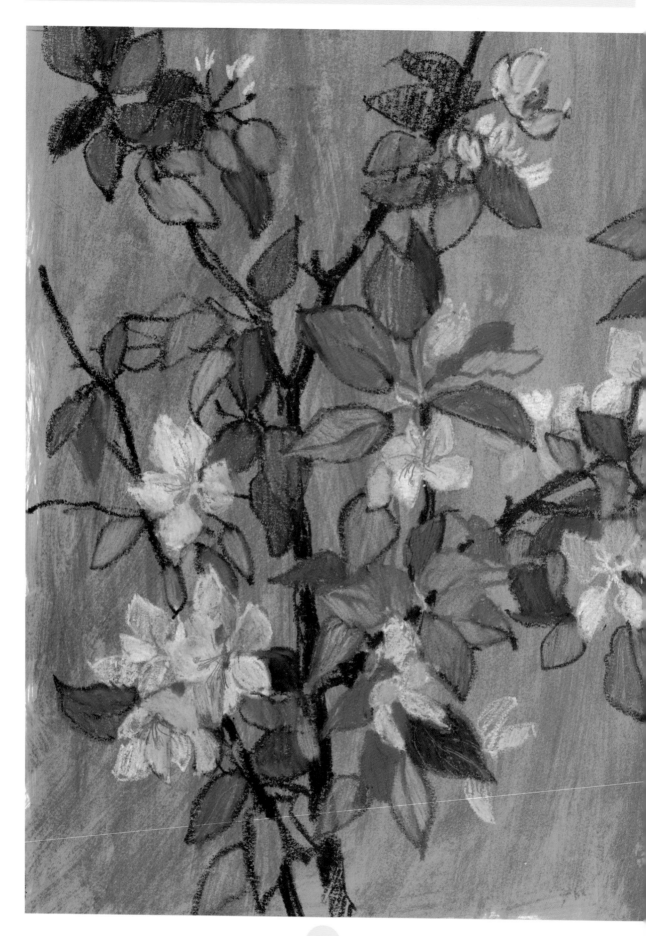

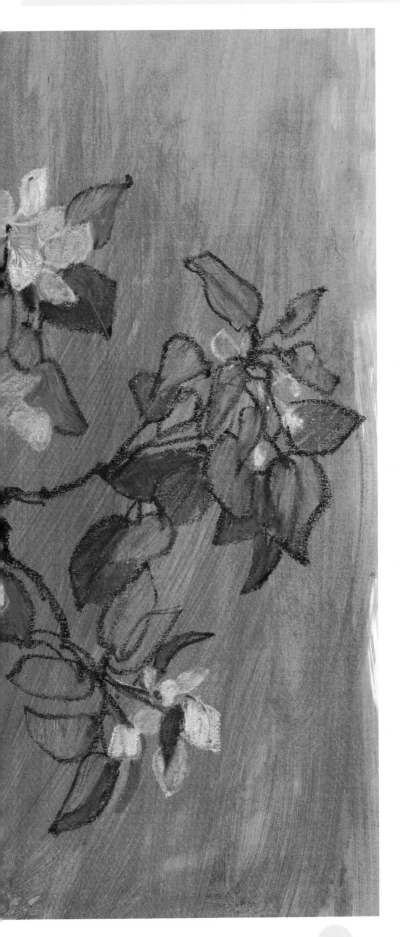

Apple Blossom

This is an experimental sketch in oil pastel on a prepared, strongly coloured acrylic ground. Using a large house painter's brush, I washed dilute yellow ochre and then crimson acrylic paint over a smooth cartridge paper. The acrylic dries quickly and acts as a primer, preventing the paper from absorbing subsequent colour applications of oil pastel.

The drawing was made directly with brown and two shades of green oil pastel. Sometimes I applied the green over the brown to create very dark tones. The blossom was added using white oil pastel over pink, and sometimes pink over white. Cooler tints were added in places with very pale sky-blue pastel. Occasional fine details such as the blossom stamens were created by scratching out with a razor blade.

Wet Media

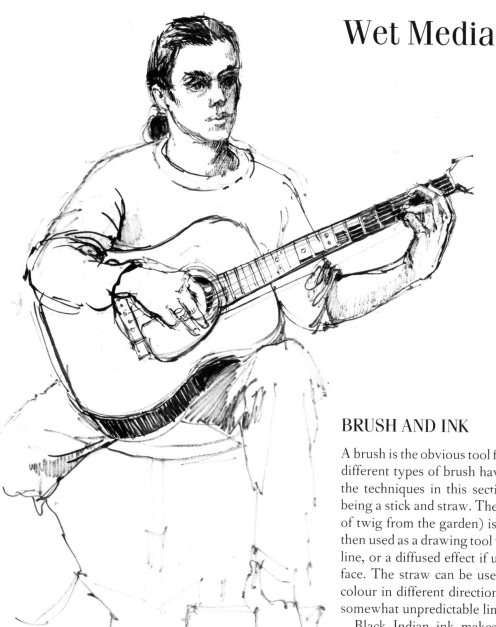

Andrew with Guitar △

This freely drawn brush and black Indian ink drawing of
Andrew learning the guitar required concentration from
both of us. I needed to catch repetitive movements of
head and hands, whilst he was absorbed in the music.
The angles of head and shoulders were lightly sketched
with the smaller brush and firmed up with the larger
one. A very fine brush soon runs out of ink, and as it
does so can be used to advantage for some of the soft-
toned shading. This dry brush line almost achieves the
character of a soft pencil but, unlike pencil, nothing can
be erased. This fact should not, however, become a
deterrent for those who wish to try drawing in ink, but
should be seen as a challenge. As with all things,
confidence is gained with practice and the occasional
blot often adds to the spontaneity of the drawing.

BRUSH AND INK

A brush is the obvious tool for wet media and several
different types of brush have been used for most of
the techniques in this section, the only exceptions
being a stick and straw. The stick (I often use a piece
of twig from the garden) is dipped into the ink and
then used as a drawing tool which gives a dry quality
line, or a diffused effect if used on a dampened sur-
face. The straw can be used to blow ink or water-
colour in different directions, giving a tortuous but
somewhat unpredictable line.

Black Indian ink makes an intensely powerful
mark, and when a brush is first dipped into the ink it
can be over-full, and will then deposit too much ink
on to the paper. To counteract this, it is useful to
have a scrap of paper handy in order to try out the
brush mark before commencing, but with practice
you soon get a feel for how loaded the brush really is.

With dry brush techniques, however, the scrap
paper idea is very useful so that the brush can be
worked out until it is dry enough to produce the kind
of line required.

Using dilute ink with a wet-in-wet technique on
dry paper can produce interesting mottled effects
and a range of greys suited to tonal drawings. Work-
ing with ink and brush or pen on paper dampened
with clean water can also produce interesting effects,
the resulting line work having a soft, blurred quality.

Tree Forms ▷

The paper was placed on a horizontal surface and blots of black Indian ink were dropped on to it quite randomly off the tip of a brush. The blots were dispersed in various directions along the surface of the paper by blowing through a straw. More blots were added and the process repeated to create a more complex grouping of branches. The resulting line-work has an angular, dynamic quality, although its course was somewhat unpredictable. Fine lines were achieved by blowing vertically down on to the paper; some of these lines shot off suddenly in two directions at once. To complete the image, a few wayward blown lines were 'tidied up' by joining them to the main branches using a fine brush-drawn line.

On the Road to Scarfskerry, Caithness ▽

A lonely spot in the far north of Scotland was the inspiration for this ink and wash drawing. It was a chilly, damp day which was probably reflected by my subconscious choice of wet-in-wet technique. In fact, several techniques have been combined in the sketch, plus the addition of white ink.

The sketch began with washes of very dilute ink which were swept across the hills and foreground fields with a large watercolour brush. Slightly less dilute ink was introduced before the first washes were dry, giving soft edges. The washes gradually became darker as more black ink was added to the solution. The buildings were then drawn with a small piece of stick dipped into undiluted ink. A small brush was used to fill windows and doors, some with dilute ink and others at full strength, and a dip pen was used for very fine lines. Foreground fields were dampened again with clear water and dilute ink was spattered into it off the end of an old toothbrush. Finally, white ink was used as a wash over some of the buildings, and for the detail of stonework.

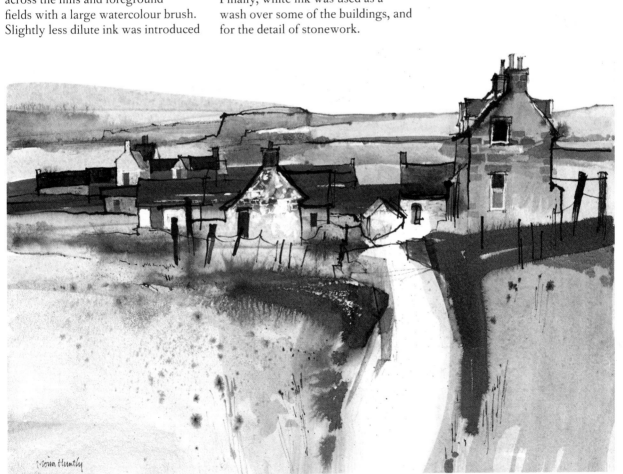

Upper Slaughter, Gloucestershire

This is another wintry scene, and these ancient Cotswold buildings made ideal subjects for experimenting with ink textures and washes. Many techniques were included: washes of dilute ink, some of which pleasantly granulated on the paper; dry brush work with large and small brushes, including a stiff hog hair brush; stick and ink; dip pen and ink, and pen work with dilute ink. The main emphasis was on using ink with a brush.

74

BRUSH AND WATERCOLOUR

The brush is a very versatile drawing tool, known to the Chinese for thousands of years and capable of a rapid and very personal free expression. Brush drawing is the drawing technique closest to painting, where line and tone can be combined with one brushstroke to suggest form. It is worth investing in sable brushes; all sizes will come to a good point so one No 6 or No 8 will suffice, although an additional very small sable is useful for fine detail. Any paper or board can be used for brush drawing and softer, subtle colour can be achieved by using a tonal support.

A drawing can be started with dilute colour and then reinforced with a darker tone, loading the brush fully to keep the flow. Various marks can be made by holding the brush in different positions: a fine line can be drawn by holding the brush vertical to the paper, and broad marks by laying the length of the brush along the paper. Thin and thick lines can be achieved by varying the pressure, and a dry brush can be dragged across the support to give broken tones useful for texture.

Exhibition Stand ▷

This brush drawing shows the interior of a large exhibition hall. I was attracted by the structure and light in contrast with the silhouetted figures. As daylight faded the lighting seemed cool and soft, and to capture this atmosphere I worked on a blue-grey Ingres mount board. The watercolour was kept to a limited range of colour with blue predominating, relieved by warm browns and a tan colour. The initial tonal drawing was made directly with a No 6 sable brush and ultramarine blue, and the pattern of light geometric shapes in the background was painted with a hog brush and opaque gouache. The foreground figures were continually changing and I made several attempts to draw them, especially to position the feet. As one person was replaced by another, a second drawing was sometimes superimposed over the first, as can be seen on the figure with her back to us.

There is enough information in this drawing and the one overleaf to be able to develop them more fully, with either gouache or pastel, into finished paintings.

Umbrella Plant ◁

This tonal drawing was made on NOT (cold pressed) surface watercolour paper with ultramarine blue watercolour and a No 2 sable. The brush was ideal for capturing a flowing feeling of plant growth with fluid, spontaneous lines. Tone was added with a No 8 brush and modified by varying the amount of water added to the wash. Central leaf veins were left as white paper or lifted out with a damp, fine brush. Overpainting with transparent washes of various greens and yellow ochre over the blue creates subtle changes in the colour of the leaves.

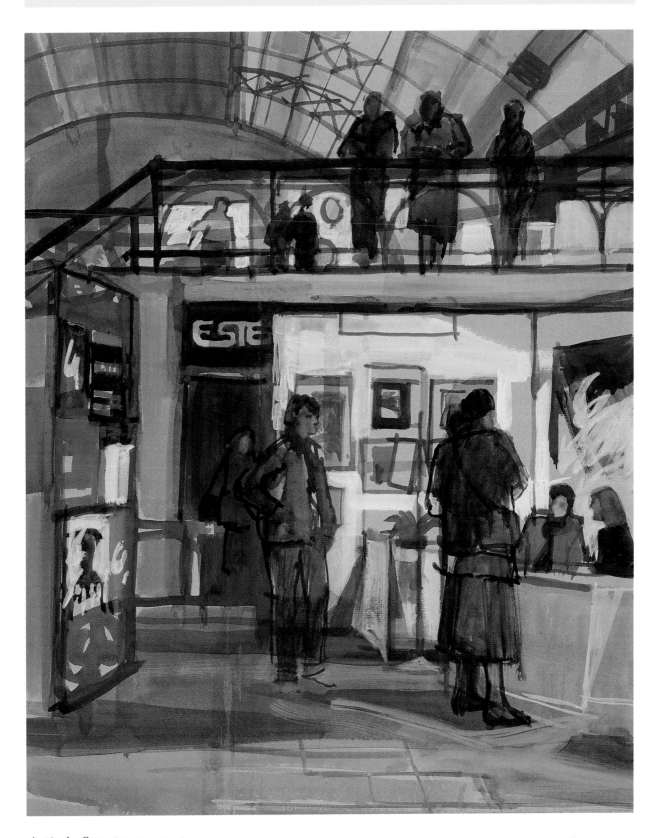

Artist's Quarter (overleaf)

The drawing overleaf shows another corner of the exhibition hall, people stopping to look at exhibits, and some chatting at refreshment tables. I was often surrounded as I made the drawing and there was a constant movement of people, so I had to make quick impressions with the brush. The drawing was started with sepia watercolour on fawn-coloured Ingres board; other colours were black, Payne's grey and cadmium red. Light areas were painted with gouache and a wide brush.

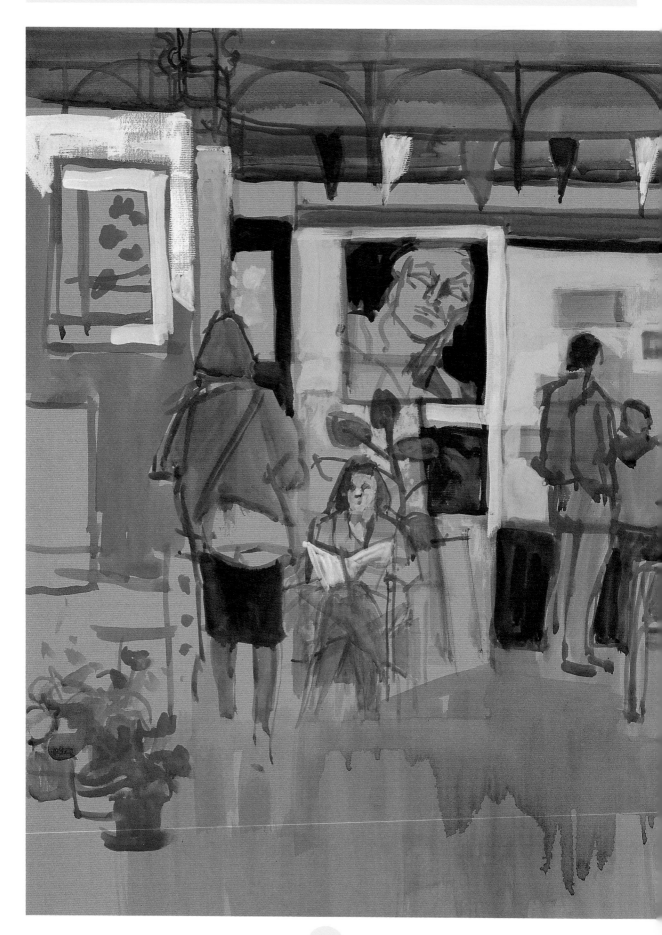

ACRYLIC AND CONTÉ PENCIL

In this section I have used acrylic paint as the wet medium, to create a prepared surface for drawing. This is not a new idea, but is based on the innovative techniques of Leonardo da Vinci, many of whose drawings were produced on a very diverse selection of coloured grounds including buff, bright orange, purple, pale pink and deep blue. His paper was coated with opaque white tinted with colour, as a preparation for silver point, pen-and-ink or chalk drawings, and sometimes a combination of media. The modern-day equivalent that I have suggested is to prepare papers with a wash of acrylic paint which provides a light-fast ground, pleasant to draw on as long as the paint is applied thinly – a thick layer of acrylic paint would be too slippery.

Haytham ▷
This drawing was made on HP watercolour paper. I brushed a thin layer of raw sienna acrylic over the paper using a 40mm (1½in) house painter's brush: this was quickly followed by a wash of cadmium red, using downward strokes of the brush. Before the red was completely dry, I washed clean water over it to remove streaks of colour, which then revealed some of the raw sienna. This produces an effective treatment for the face and also provides a sympathetic background on which to draw. The black Conté pencil drawing is concentrated on the head and is deliberately understated on the body.

Mountain Landscape, Sutherland ▽
Pale pink acrylic paint was brushed over smooth-surfaced, heavy cartridge paper and, when it was dry, the mountain landscape was drawn with sanguine pencil. Leonardo da Vinci was reputed to be the inventor of pastel and probably the first artist to use red chalk. Many of his red chalk drawings were produced on pale pink or red prepared surfaces, sometimes heightened with white chalk.

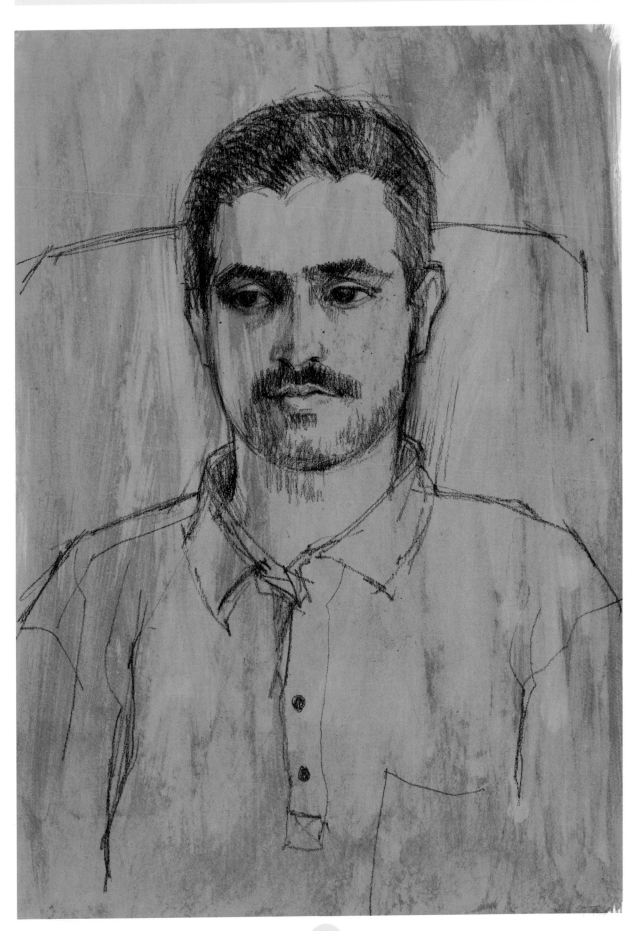

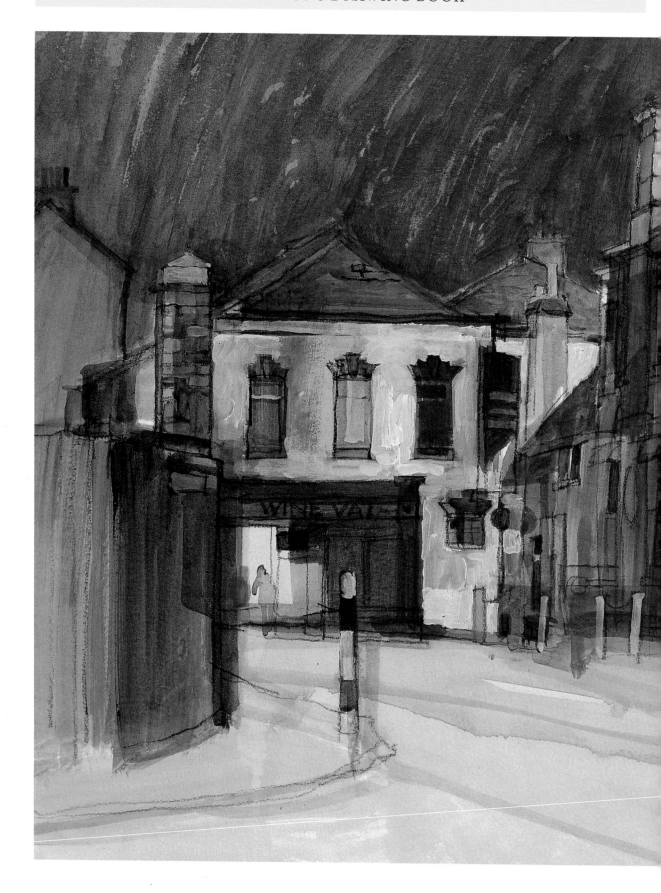

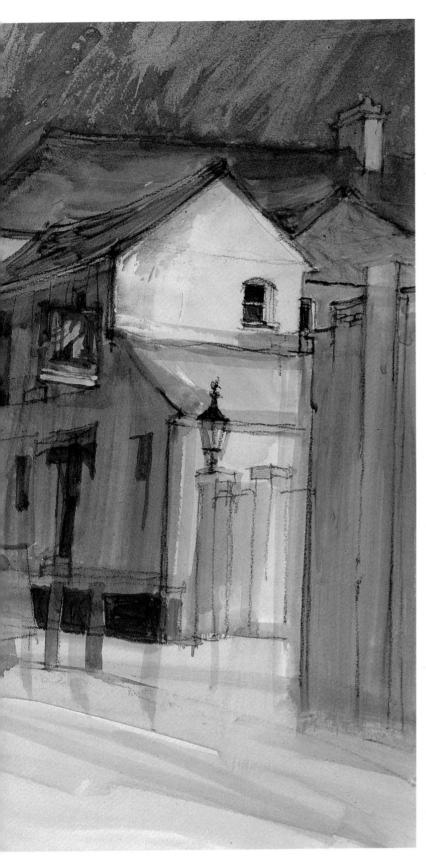

Southgate, Gloucester

Here I have combined a more elaborate acrylic underpainting that includes washing-out techniques, with a simple black Conté pencil drawing. The washing out is particularly noticeable in the sky; results are not always predictable, but the technique creates a lively surface movement. Most of the colour was applied in thin washes and the drawing superimposed when the washes were dry. The drawn line did not necessarily follow the edge of the wash. A few adjustments were made on light areas of the image with thicker, more opaque acrylic paint.

4
SKETCH BOOKS

Many artists regard their sketch books as sacrosanct, the drawings being very personal and intimate, often revealing the individuality of the artist. For the viewer, it is fascinating to observe and share in the spontaneous inner thoughts of artists.

Sketches may be regarded as slight, often unfinished drawings, but they can be important works of art in their own right as, for example, Constable's and Turner's sketches are regarded today. The purpose of a sketch can be very varied: sometimes a preliminary rough idea for a composition, or a rapid note of lighting effects, or a brief impression of a subject, gathering the essential character in a few well-chosen lines. Alternatively, a sketch might be produced out of the sheer joy of drawing and from a wealth of vision, and not necessarily for any particular purpose.

Impressions are quickly expressed with a general outline, but 'on the spot' quick sketches to record colour and atmosphere can be made with watercolour, felt-tip pens or pastel pencils. When drawing in colour, Degas and Monet often used pastel, and Cézanne used watercolour for the broken line work in his colour sketches.

My sketch of the peninsula was made with watercolour and coloured felt-tip pens. These pens are not waterproof and so the line flared into the watercolour washes in places. For the Venetian sketch I used a waterproof drawing pen, with fibre- and felt-tip pens for the colour notes. The two-minute sketch of *The Listeners* was made with a 4B pencil.

The Listeners (left)

Aberdaron Peninsula, North Wales (above right)

From the Accademia Bridge, Venice (below right)

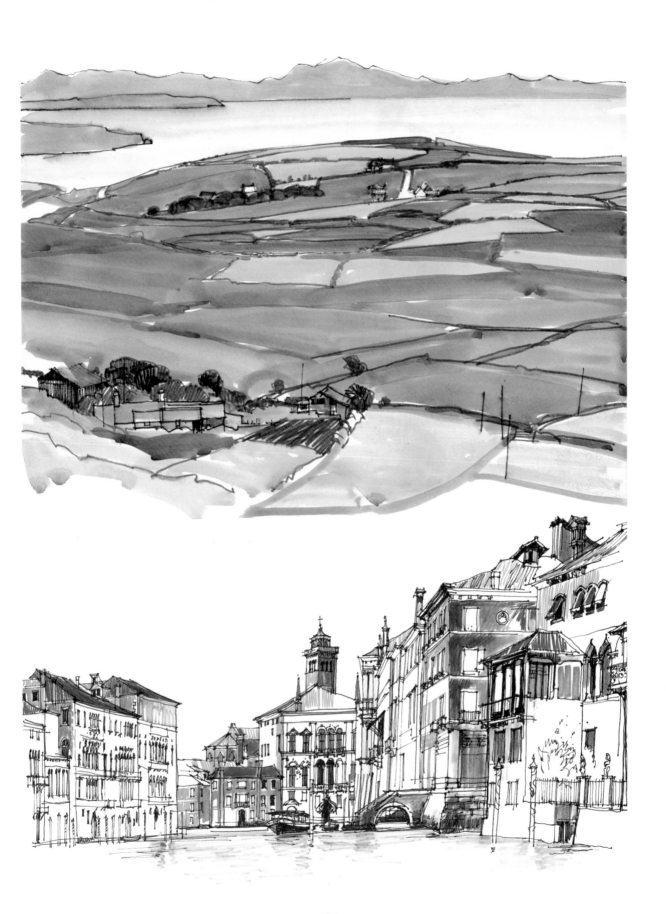

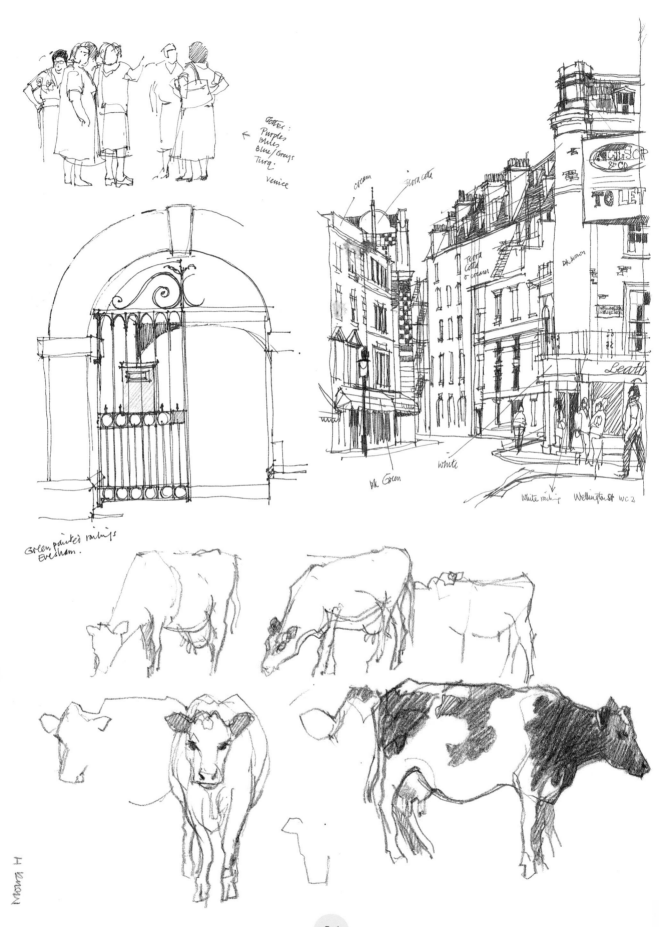

Moira Huntly

Nr. Chagford
Devon

Fish Market
Venice

Travelling Sketch Books

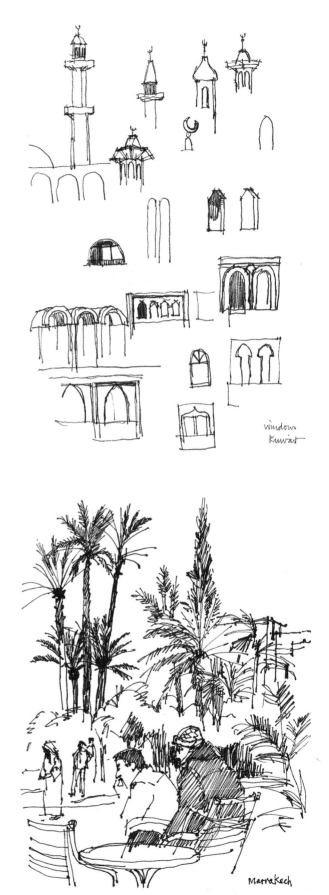

Windows
Kuwait

Marrakech

If I am travelling light I take the minimum of equipment with me: a small sketch book, waterproof pens, coloured felt-tip pens and a 2B pencil, plus a small retractable blade for sharpening the pencil. This equipment can be extended to include a miniature watercolour box, a No 6 sable brush (which will come to a good point for fine work) and a small plastic screw-top bottle for water. Large colour work can be carried out on mountboard, which will save you carrying a drawing board.

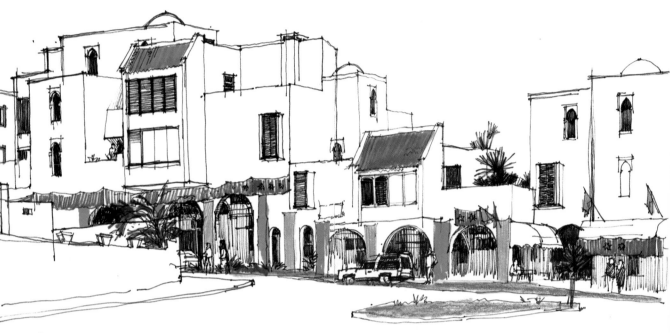

Agadir

Marrakech

Sometimes we have to make sketches under difficult circumstances, as when I visited the Middle East, where I suffered the disadvantage of being a woman and found it prudent to draw surreptitiously from inside the car. There was so much to fascinate and visually stimulate, that this was very frustrating from the artist's point of view – the mosque and various window details had to be drawn rapidly as the car sped along a motorway in Kuwait. Drawing in Morocco was easier, and I found that outdoor cafés made good, unobtrusive vantage points.

Having to sketch rapidly encourages keen observation in order to make quick impressions and gain a flavour of the country.

89

5
DRAWING FOR PAINTING

Sketches are often a starting point for a painting, and the shapes and patterns observed in a subject become more important than the subject itself as the drawing progresses. In my own drawings, I try to seek out and enlarge upon the abstract qualities that attracted me, and then establish these as the main elements in the painting. I look for a clutter of shapes, spaces between, geometric forms and spatial relationships, and often find this in harbour subjects, a group of figures or buildings on different levels, such as can be seen in the sketch of Portscatho in Cornwall.

Maldon, Essex (right and far right)
Pen and ink (drawing); oil (finished work)
In this composition, the simple foreground of big shapes served as a foil to the busy background of boats and buildings, and these in turn were placed against a large empty sky.

Portscatho, Cornwall (below left and right)
Brown Conté pencil (drawing); watercolour (finished work)
The houses and boats are clustered together to make overlapping shapes, whilst in contrast, the foreground is more open with bigger shapes and spaces, and diagonal lines echoing some of the rooftops.

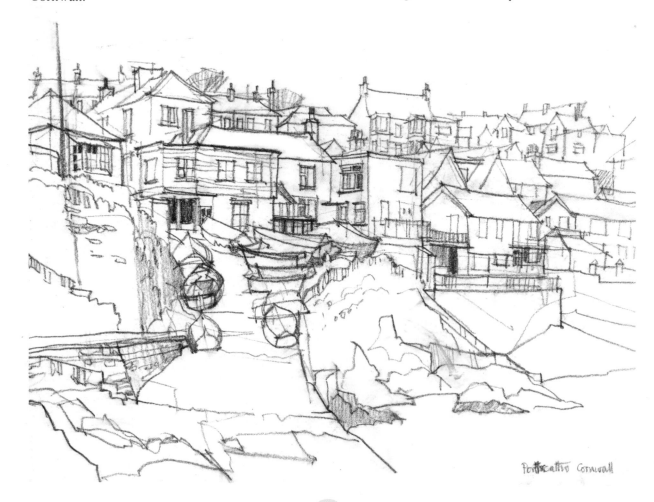

Portscatho Cornwall

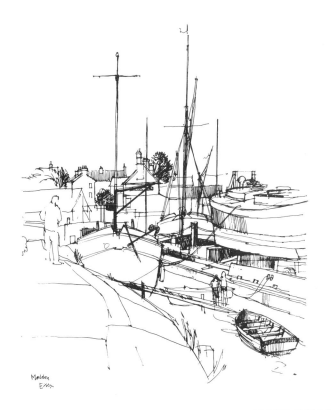

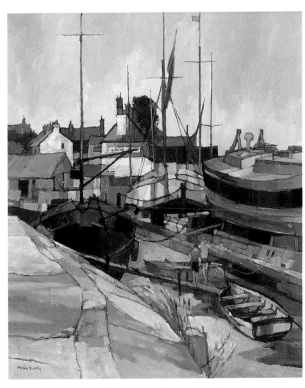

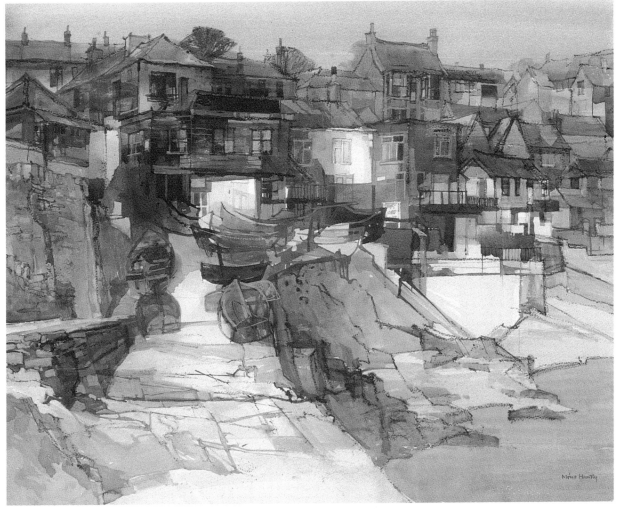

DEMONSTRATION

Mevagissey, Cornwall

Here again is a subject that fulfils my liking for a jumble of shapes, a kaleidoscope of brightly coloured buildings linked with a marine subject and a simple open foreground. I visited this Cornish fishing village in winter when it was free of crowds of visitors and there was freedom to observe and sketch. I was attracted by the rows of houses, one above another, nearly all different, and by the shape of the quayside leading the eye to the Shark's Fin Hotel on the corner. This building, with its triangular roof, is quite dominant in the sketch and the few figures present are all gathered within that important area of the composition.

The open line work in the drawing, with a minimum of tone and no real direction of light, allowed freedom of interpretation in the studio. I chose watercolour to create a freshness and clarity of light.

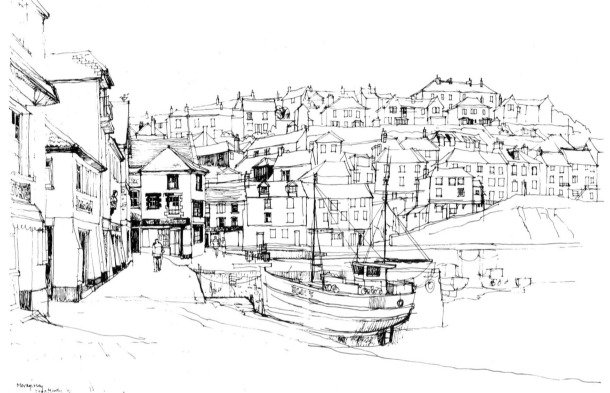

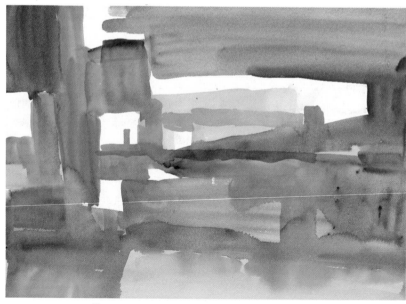

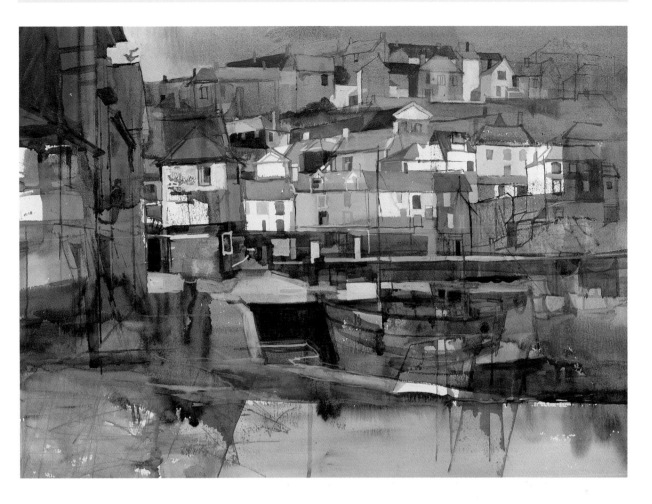

STAGE 1 *(below left)*

The watercolour paper is 140lb NOT surface (CP), and to give a seaside gaiety to the scene I used a simple palette of ultramarine blue, raw sienna, burnt sienna and olive green. I studied the sketch, looking for basic divisions in the composition and trying to simplify the houses into a narrow band of horizontal light in opposition to the vertical buildings on the left.

The first washes were applied with a large brush in broad, uncomplicated areas: blue for the sky, water and building in shadow, raw sienna for the foreground and to give a feeling of warm sun on the buildings. Small areas of burnt sienna were added around the focal point of the composition, and olive green provided a link between the cool and warm colours. At this stage the shapes are quite abstract.

STAGE 2 *(above)*

I commenced drawing the subject with a sable brush and burnt sienna watercolour, changing to a soft blue for some of the distant houses to give recession through colour. The line work was freely superimposed over the washes, sometimes creating accidental colour divisions across the fronts of buildings and the side of the fishing boat. These can be retained as happy accidents or adjusted with opaque gouache later, as the case may be. Windows and doors were interpreted as a pattern of squares and rectangles in different colours, with darker accents here and there. The boats are less defined, the line work 'lost and found' against the far side quay, retaining a certain ambiguity.

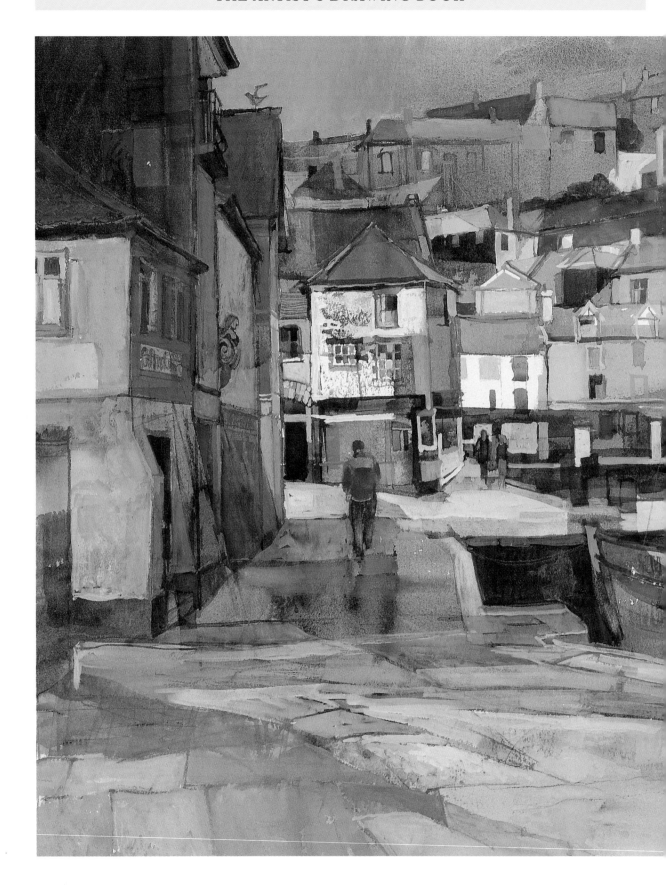

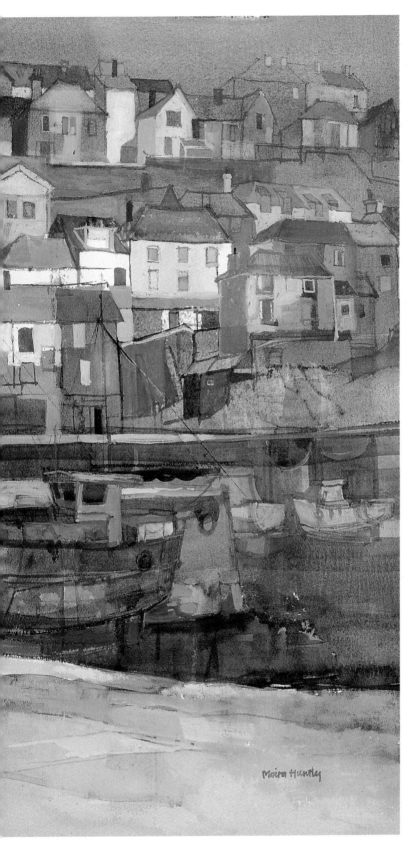

STAGE 3

Many refinements have now been made with watercolour and gouache, though keeping to the initial limited palette. Unwanted dribbles have been lifted off by wetting with a brushful of clean water, then blotting with tissue, and repeating the process until most has disappeared. Figures have been introduced and the drawing tightened up in places, much of it remaining faithful to the original sketch. The foreground has been enlarged, but kept subtle in treatment as a foil to the busy concentration of buildings. Gouache has been used to reinforce light areas and soften some of the washes, and on hilltop buildings dilute gouache was applied, allowing some of the blue wash to show through and giving a softness to the light in that area. The harbour remains partly in shadow, and the boats have been kept subservient to the strongly lit buildings beyond.

Drawings for Reference and Composition

Commissioned work often requires a different approach to drawing, the emphasis being on accuracy and detail. The drawing below of the arched gateway is full of information, with plenty of scribbled notes about colour and general effects. Sometimes I back up such drawings with photographs, which are useful as a reminder or for details if I run out of drawing time, but I never rely on photographs alone. It is only by drawing that I 'see for myself' and become familiar with the subject. Occasionally a client allows a free hand to interpret a subject, but even so it is wise to collect as much information as possible and then select in the calm of the studio.

Soft pencil is a good medium for making tonal roughs for compositions. The portraits opposite are quick sketches carried out as preparation studies for a self portrait and details are only hinted at. It is helpful to study self portraits by past masters and observe the composition: many show head and shoulders and some include one hand, often holding a palette, or a letter as in one of Gwen John's self portraits.

The rough idea for a harbour painting is loosely based on a drawing of Tenby, but the rough seeks to simplify the composition into a pattern of tone and shape. It is a stage in the translation of a drawing into a painting and there is often a reappraisal of the shapes recorded. We may choose to exaggerate certain shapes or concentrate on one particular aspect, refine or simplify the subject, or even alter the format of the original drawing.

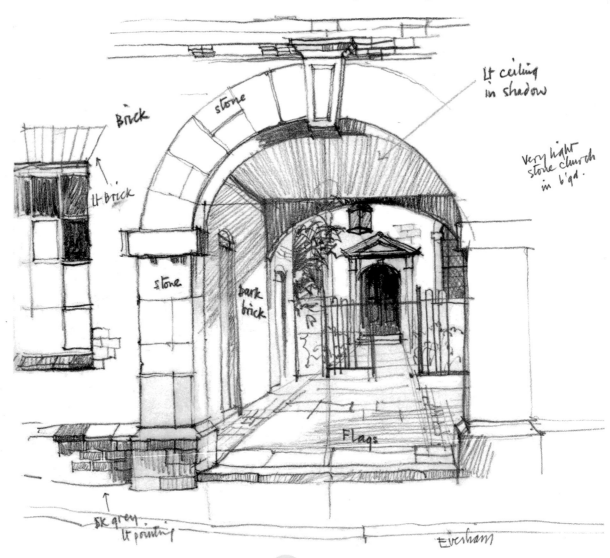

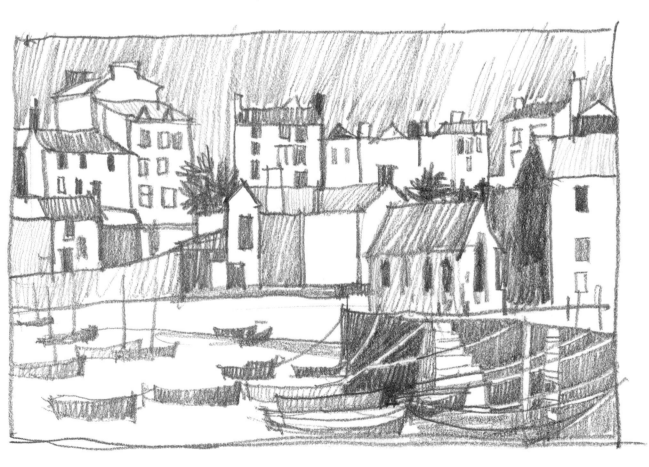

Abstract Drawing for Painting

Now and then it is good to try things out and not limit your approach. The drawings shown here are experimental abstracts made from arrangements of cut paper shapes and used as an aid to composition. The shapes can be rearranged *ad infinitum* and many different drawings made. This idea leads on from the exercises on pages 30–31, where an abstract collage was introduced for observation of shape and tone.

Although the shapes are abstract, quite often a particular arrangement can take on a meaningful representation. I am not sure what to make of the first drawing yet – perhaps it has connotations of an urban landscape, street signs, posters, or perhaps it should remain purely abstract. The drawing opposite did bring images to mind, mostly still life with melons and apples. As a result, I made a study of cut apple shapes with their subtle curves and combined it with the abstract composition to produce a later painting.

The demonstration painting overleaf of *Decanters and Candelabra* was developed from a similar abstract composition.

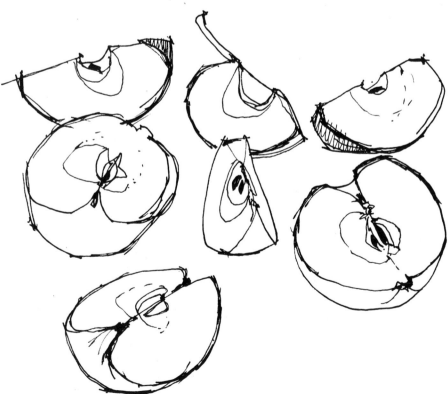

DEMONSTRATION

Decanters and Candelabra

This demonstration shows the development of a totally abstract concept into a painting which has recognisable subject matter but retains an abstract quality. It is quite a challenge to begin a painting without knowing from the start what the final nature of the subject might be. Simple abstract shapes and their distribution in the composition can often suggest something real to our subconscious – it might be the colour, or dark shapes against light that jog a memory, or the abstract could be viewed the other way up or on its side and different subjects might suggest themselves.

As the years have gone by I have accumulated numerous sketch books, and so I have a huge fund of information and ideas to call upon once the sphere of subject matter has become apparent. Thus a painting is commenced without any preconceived ideas, leaving space for the imagination.

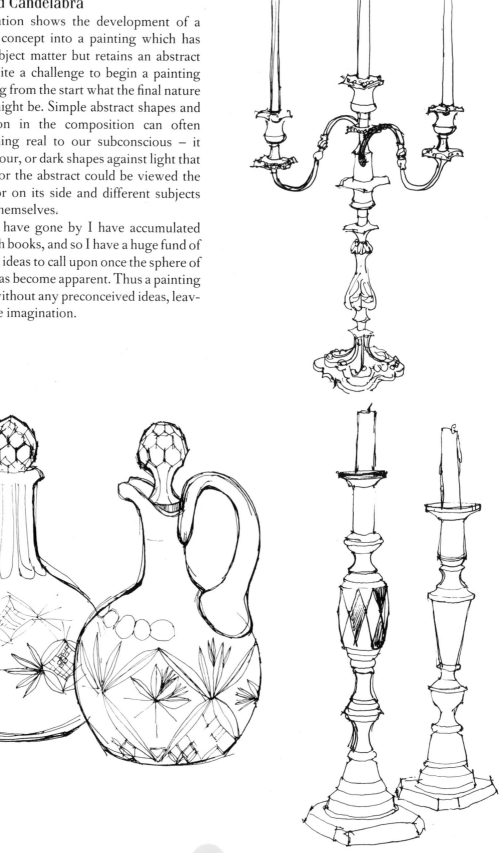

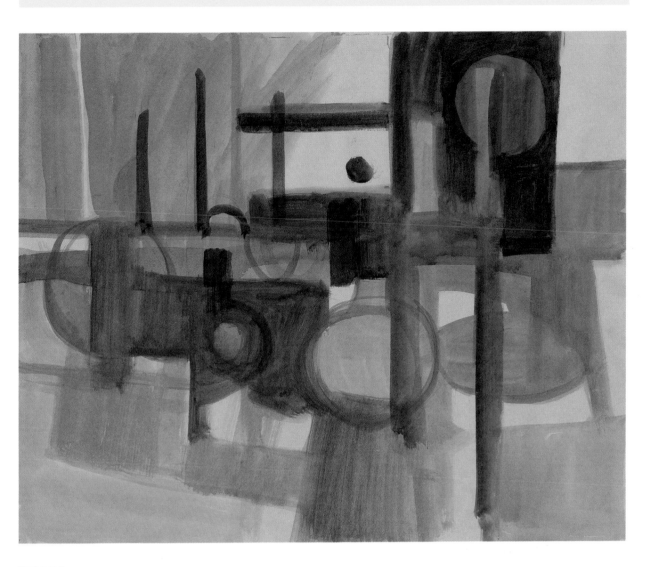

STAGE 1

In the beginning the thinking was purely abstract, with no relationship to actual objects. As large divisions of the image area were made, the Golden Mean ratio of five parts to eight was constantly at the back of my mind, and forming the composition became a balancing act. The format at this stage was very simple, mainly rectangles, squares and thick lines painted with a 40mm (1½in) house painter's brush using raw umber and burnt sienna watercolour. The support was a light grey Ingres board. A few subtle, curved movements were introduced and then more complex dark shapes were overlaid with Payne's grey and burnt umber, attempting to divide the picture space into balanced areas of tone. Gradually, although without intention, the abstract shapes and their distribution began to take on connotations of reality — a table top, a rounded bowl, window panes and a pattern of light from the window all perhaps suggest themselves. At this point I browsed through my sketch books, looking for studies of still-life objects which might fit into the theme that conveyed itself.

With imagination, the thin verticals in the composition could become candlesticks, circles and semi-circles lent themselves to the more generous proportions of decanters, and fruit completed the scenario. Following these thoughts, various isolated drawings in my sketch books were brought together to play their part in the composition, and the chosen objects were freely drawn with a brush, superimposing their shapes over the initial abstract beginning.

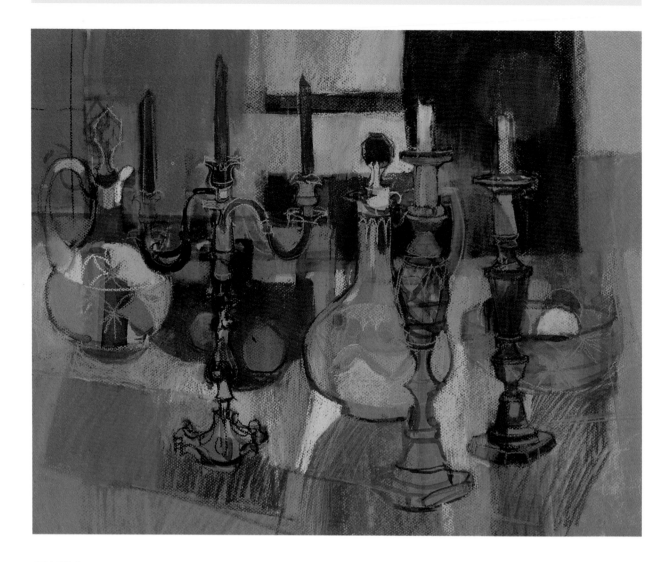

STAGE 2

Keeping to watercolour and changing to a smaller brush, the placing of objects continued and a literal interpretation gradually evolved. The smallest dark circle became the stopper of one of the decanters, while other circles were enlarged to fit the format of the decanters themselves. Some verticals were convoluted into the decorative shapes of candlesticks and candelabra, and the varying characteristics of each were carefully observed. A choice had to be made on the relative positions of each candlestick base, and by selecting slightly different positions more interest was generated in the composition than if the bases had remained on the same level.

Colour became the next consideration. A rough distribution of warm colour had already been established at the abstract stage with watercolour, and the intention from the start was for this to be used as an underpainting, the final work being developed with soft pastel and pastel pencils. A more careful drawing of the decanters and candelabras

was now superimposed over the watercolour washes with pastel pencils, and then cool colour was introduced, mainly over areas of dark tone using dark soft pastel which, by working in between the objects, at the same time defined their lighter-toned forms.

From now on there were continual choices to be made as to which areas of the initial abstract concept to keep as part of the painting, and which to discard or adjust. Such alterations to the underpainting can easily be made with the good covering power of pastel, and so the colour was developed and the ornate decorative elements brought out with pastel drawing.

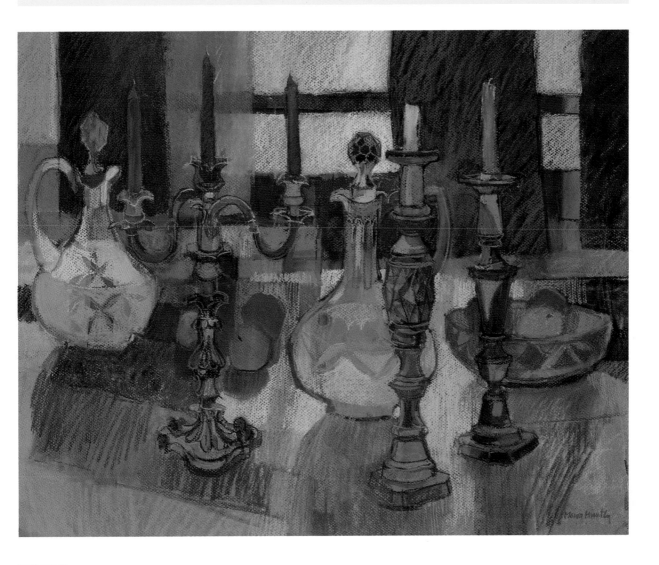

STAGE 3

There is always a danger that the objects might 'take over' and we begin to lose some of the initial abstract ideas. Knowing how far to go or when to leave alone when completing a painting is one of the most difficult decisions to be made. In this instance I felt that the original dark-tone areas needed to become more integrated, and so the central area was modified with a mid-tone of blue-grey pastel. More darks were added to the background, repeating the rectangular motif but varying the widths of each rectangle. In the final stages the two glass decanters became emphasised, because they were light in tone and had the brightest colour of all the objects and their shapes were rounded by comparison. Most of the other objects were painted in such a way that they integrate closely with the background, with the exception of the vibrant touch of bright blue on one of the candles. Other blues were picked up in the shadows on the table, and the khaki colours of the candlesticks were repeated in the table and back-

ground. The aim throughout was to achieve an amalgam of foreground objects, all of them fusing together against the very positive arrangement of background shapes, yet to retain a balance between realism and abstraction.

6
INTERPRETATIONS

This chapter deals with interpreting sketches as paintings, bringing out different aspects of representation, colour emphasis, and thinking out the composition. An artist should extract from a sketch, looking for shape, pattern value or colour, and selecting and intensifying his vision rather than merely reproducing.

The pen drawing of Woodbridge below was made on site with the object of recording accurately sufficient information to translate into paint when back in the studio. I actually painted several interpretations of the subject.

I was attracted to the design elements brought about by the horizontal line of the buildings and the jetty bisected by the vertical masts, and their differing heights. The two nearest boats provide an interesting change of geometry, with their diagonal placement leading into the picture.

Both of the interpretations shown opposite are painted with watercolour and gouache on large pieces of watercolour paper.

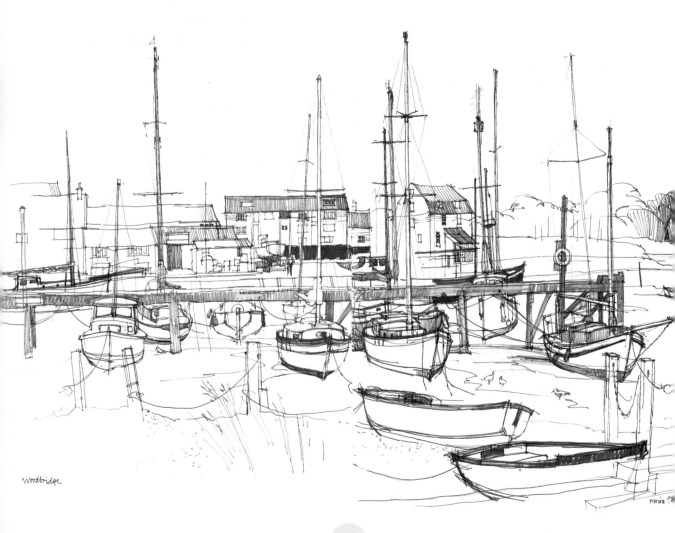

Woodbridge

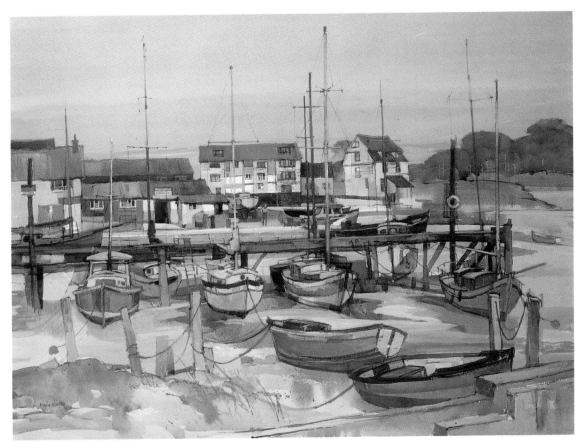

△ Woodbridge, Suffolk I

Here, the interpretation has a light airy atmosphere with a gentle, warm colour emphasis based on washes of raw sienna, raw umber, burnt sienna and olive green. Most of the elements in the sketch have been adhered to, importance being given to where the masts cut across the buildings and the intervals between them as seen against the sky.

Woodbridge, Suffolk II

In this interpretation, my main interest lay in the choice and application of the colour. The sky is a narrow strip of dramatic and varied deep blues painted with downward strokes of a wide brush, and I have enlarged the area of foreground and flooded it with light, using a wash of raw sienna. The blues in the sky are repeated in some of the boats, and it is interesting to note that the masts are less emphatic than in the sketch-book drawing. I also made a few changes to the arrangement of the boats and emphasised the foreground posts.

Colour Sketches

A few days in Venice leave a lasting impression – it is a dream city full of atmosphere, people, wonderful architecture and a visually exciting vista around every corner. The watercolour sketches on these two pages were made on the spot in the same vicinity, one in the morning and one in the afternoon. They were worked on toned paper, which I often choose for outdoor work to eliminate the glare which a white paper can produce. The morning light tended to coolness, and so I painted the morning interpretation with cool shadows over a cool grey paper. When I came to start the afternoon painting the light appeared to be warmer, and so I chose a warm grey paper and painted over this with warm washes.

Fruit Stall, San Barnaba

I chose a cool grey Ingres paper and applied broad washes of cool viridian watercolour over the big masses of foreground shadow and shaded parts of the buildings, using a large brush. Drawing was superimposed over the washes with a small brush and Payne's grey or viridian watercolour.

In this composition, the main area of light is concentrated in the middle distance and on the tall building, and this is emphasised by the dark canopy of the stall and the silhouetted figures in front of it. To emphasise the intensity of light still further, I painted those areas with creamy opaque gouache.

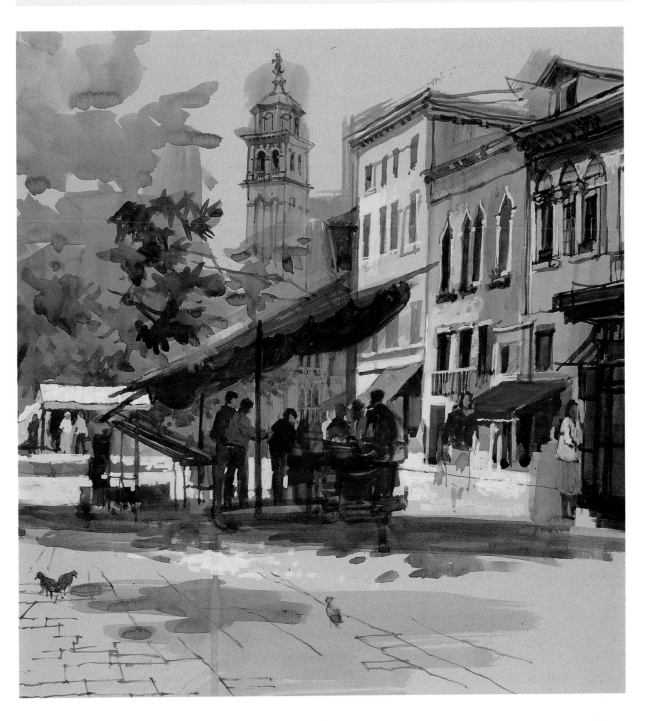

Campo San Marguerita

When I came to start the afternoon painting the light appeared to be warmer, so I chose a warm green-grey Ingres board and interpreted the initial tonal underpainting as a warm, light red colour. Shadows and tones were broadly indicated with burnt sienna watercolour, and then I tightened up the shapes and indicated details by drawing over the washes with a fine brush and olive green watercolour. In this painting also, the dark canopy and group of silhouetted dark figures contrasts with and emphasises the areas of light, an effect which I have intensified with touches of pale pink gouache.

STILL LIFE WITH SWISS CHEESE PLANT

This series of watercolour drawings explores some of the compositional interpretations of this still-life group. All have been executed at some speed with a large brush and watercolour, the flowing medium enabling a freedom of approach.

The group is dominated by the *Monstera deliciosa*, commonly known as Swiss Cheese Plant, presumably because the holes in the leaves give rise to a comparison with an Emmenthal cheese. It is an exciting plant to draw – the strong forms are full of movement and at the same time have a sharp angularity. The cut-edged shapes are almost menacing in character. On the whole, the objects accompanying the plant remained the same for all the interpretations, the exception being the introduction of an orange teapot. All the pots and fruit have in common very rounded forms, which serve as a nice foil to the incised forms of the leaves.

A cool background, dark leaves and a bright orange cloth were the main elements of the group, and it was the brilliance of the warm colour that particularly caught my eye. It seemed appropriate to interpret the group on different coloured grounds; two were drawn on a neutral buff-coloured paper, and the third on bright orange. It is also interesting to note that each composition has been worked out on a different image size, one being vertical, one horizontal and one almost square. The choice and number of colours used in the initial brush drawing was very limited, and this was a deliberate ploy so that concentration was centred on aspects of the composition and arrangement of shapes rather than becoming too involved with the colour of individual objects. The still-life group did, however, have a general influence on the choice of limited colour. On the buff-coloured ground (A and B) the warm colours chosen were cadmium red, burnt sienna and burnt umber, and the cool colour was French ultramarine blue. This blue, when painted over cadmium red or burnt sienna, creates a strong, rich, dark tone. On the orange ground (C) the brush drawing was confined to French ultramarine blue, which again effectively gives warm browns and darks in conjunction with the orange base.

When exploring the various compositions which can be made by re-arranging the objects in different

Composition A △

This study was made on buff-coloured paper, starting very rapidly with a 25mm (1in) house-painter's brush. I did not worry about dribbles of wet paint running down the support. The objects and cloth were blocked in with burnt sienna and cadmium red watercolour, and the background indicated with French ultramarine blue and burnt umber. The drawing was developed more fully with a smaller brush and ultramarine blue, a blue which gives a rich dark line when worked over cadmium red and burnt sienna.

Composition B ◁

A buff-coloured ground was also used for this study. Here the group was placed on a very low table, a viewpoint which revealed much more of the cloth and less of the background. The objects are clearly lit and the pattern on the jug and the shape of the leaves with their deep incisions are easily perceived, whereas in A, the jug is in shadow and most of the leaves are silhouetted against the light background. However, to a certain extent both of these interpretations show some counterchange in the tone of the leaves against their backgrounds, light against dark and vice versa.

Composition C △

The brilliance of the orange cloth led to a trial on an orange ground for this version of the still-life group. The principal interest here was the strong pattern of light and shade and the linking of dark objects and plant against a light background. French ultramarine blue was the only colour used to mass in the shapes, and the resulting warm, dark tone of this blue on the orange base is very pleasing. Some definition and repositioning of objects was made with pastel pencils, and areas of background light were broadly indicated with the side of a soft pastel.

sequences, it is also important to pay attention to the spaces between objects. These areas, sometimes referred to as negative shapes, form an integral part of the composition and are therefore equally as important as the objects themselves. To further this aspect of the exploration of composition possibilities, the group was placed on different eye levels so that new viewpoints were created. For example, if a still

life is placed on the ground, the objects are more rounded in aspect and more can be seen of the surface on which they stand.

If wished, these preliminary studies of the group could be regarded as underpaintings. Each one could be developed into a finished painting by the addition of either gouache, acrylics or pastel, as was used for the final painting overleaf.

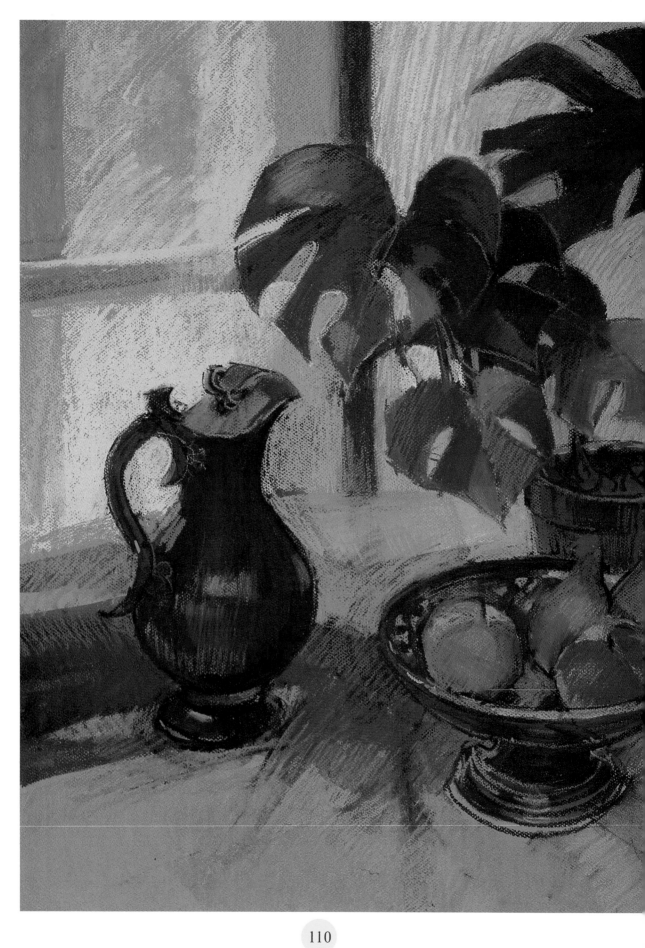

Still Life with Swiss Cheese Plant

This watercolour drawing has now been fully developed as a finished painting with the addition of soft pastel and pastel pencils, allowing some of the initial dark watercolour to show through. A strong pattern of dark tones and shadows between the objects and the dark shapes of leaves against a light background has been retained, and more has been made of the softer, dappled light filtering through the leaves on to the fruit. Local colours which have been introduced are carefully matched to the tones of the initial laying in; for instance, the design on the jug – clearly to be seen in the vertical composition (B) – is only hinted at here, described entirely in low tones.

7
CREATIVE
EXPLORATION

In this chapter I have given suggestions for making experimental drawings with various media combinations, and provided an introduction to some unconventional techniques. Working with mixed media can provide an opportunity for taking chances, being inventive and generally approaching a subject in a different way.

Coppice ▷
Black Indian ink, gouache, oil pastel and watercolour combine here on pale grey Ingres paper. The trees were drawn with a stick dipped into the ink, changing to a pen for the undergrowth. Oil pastel was superimposed over some washes, and later washes were superimposed over the pastel.

Winter Landscape ▽
This drawing in black Indian ink, grey oil pastel and white gouache was produced on an unconventional background. I had been making monoprints on rough-textured, mid-toned pastel paper, using black printing ink on a glass slab. I partially wiped the slab with a turpsy rag and took a print of the remaining blobs of ink. The resulting image reminded me of a landscape, with the blobs of ink as trees, and I interpreted it as a snow scene.

Coloured Ink and Water-soluble Pencils

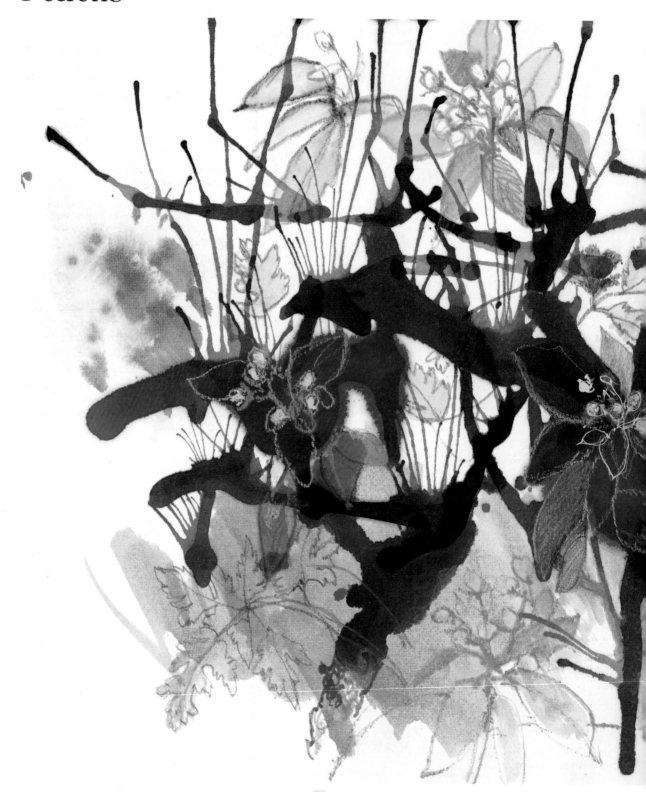

Undergrowth

This experimental drawing with coloured inks and water-soluble pencils explores the variations in the character of line produced by these different media. I used a smooth hot-pressed watercolour paper and created strong, energetic ink lines by pouring ink directly on to the paper and then tilting it to cause the ink to run in different directions. A certain degree of control can be achieved with careful manipulation of the paper. Before the ink was dry, I blew downwards vigorously through a straw, and this had the effect of fanning the ink outwards in fine lines.

Keeping to a limited palette, I chose three inks: olive green, indigo and cobalt. Some of the cobalt was diluted and brushed onto the background, and the resulting image reminded me of plant forms. I imagined gnarled branches and wind-blown grasses, and so I enlarged upon this theme by picking a few plants and adding carefully observed forms to the imaginary shapes. The plants were drawn with blue-green, mid-green and olive green water-soluble pencils, sometimes blending them with a wet brush and sometimes dipping a pencil into water before drawing. This alters the strength of the colour and darker pigment is suddenly deposited on the paper, until the pencil runs dry. The resulting quality of line is subtle, giving lost-and-found edges and varied emphasis to parts of the plant.

DEMONSTRATION

The Waiting Room

This charcoal drawing of figures has been combined with collage, and the hard, cut edges of the collage papers are in total contrast to the lost-and-found soft lines of the charcoal medium. The interest lies in the mixture of abstract pattern and realism.

FIGURE 1

The idea of the subject and using collage was already in my mind when I drew the figures in the studio, so the background was left blank. The drawing was fixed, and I then made a tracing of the silhouettes of the figures and chairs, rubbed soft pencil over the back of the tracing and transferred it on to another piece of paper. The second piece of paper was used to work out shapes and tones in the background before cutting paper. I keep a small folder for odd

pieces of coloured papers, newspaper scraps, textured papers, wallpaper offcuts and so on, and this provides a variety of choice for collage.

FIGURE 2

A broad layout pencil was used to fill in tones roughly, and when the arrangement was complete the background shapes were also recorded on the original tracing paper. This becomes the pattern from which the paper shapes are cut. I selected a warm colour scheme plus black, in contrast to the white paper and grey charcoal. My preference here was for a subtle range of warm colour, the brightest being a deep, gingery yellow.

Each part of the background was traced on to the appropriate colour and the shapes cut out and tried against the original drawing; this can be quite

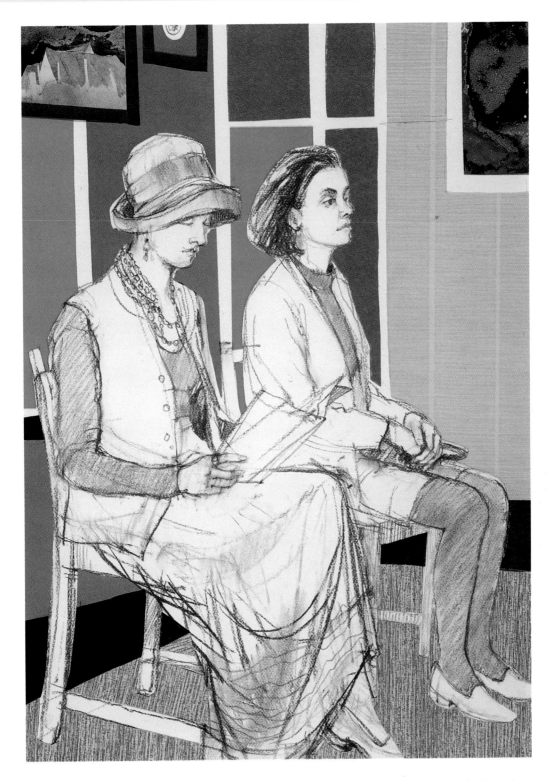

laborious if the background is very complicated. Nothing is pasted down at this stage so, as the work progresses the choice of paper can be altered, since the arrangement is in flux.

FIGURE 3
The collage was now complete and each piece was stuck down with an acrylic medium. The resulting image can be regarded as a finished work in itself, or act as the inspiration for a subsequent painting. The concept of bringing together drawing and collage in the same work is not new and many artists, especially the early Cubists, experimented with mixed-media drawing and painting. The combination offers a different sense of reality in picture-making and widens the vision.

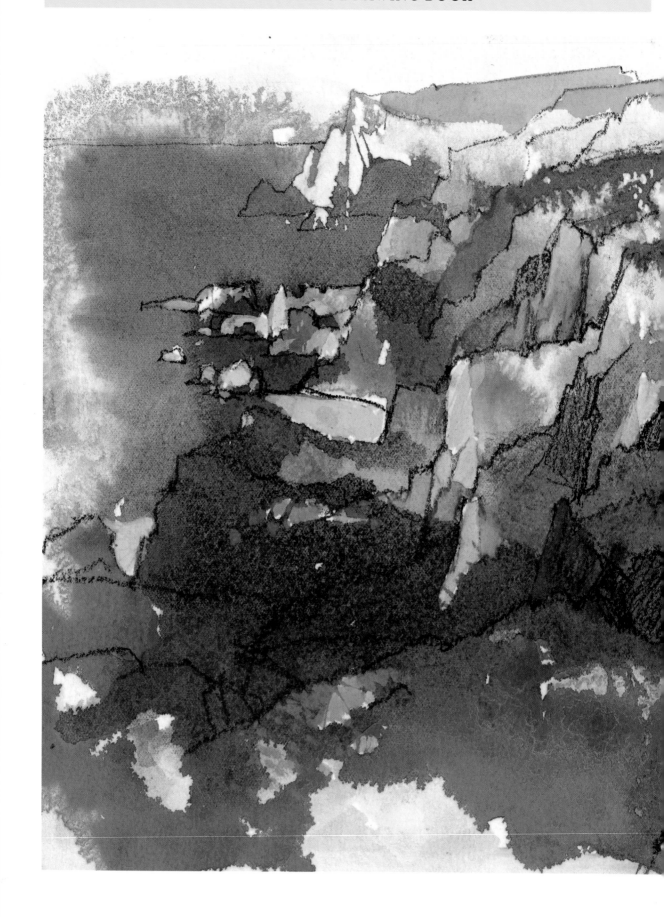

Coloured Ink, Sanguine, Charcoal Pencil and Gouache

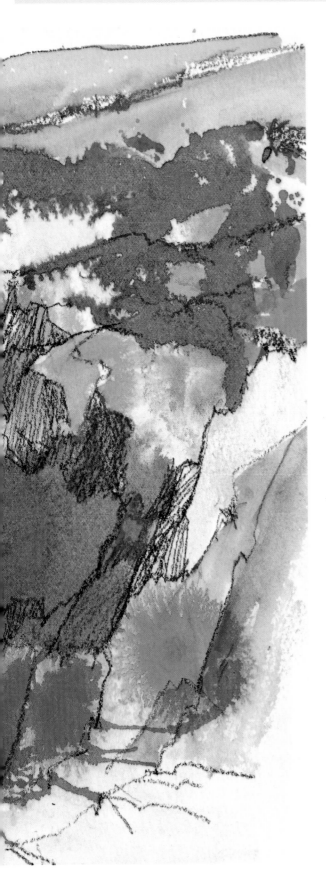

Near Musselwick Bay, Pembrokeshire

Part of the Pembrokeshire coast in South Wales became the subject for this mixed-media drawing in coloured inks, sanguine pencil, charcoal pencil and touches of dilute gouache. The drawing was worked over a prepared colour ground of olive green, crimson and cobalt ink, poured on to heavy watercolour paper which had been thoroughly wetted. This causes the coloured inks to flare and fan out, and the colours will mix on the wet surface, sometimes precipitating. Runs can be induced before the ink finally sinks into the paper, and the result can be a rich and varied surface to stimulate the imagination.

The line work was superimposed with sanguine and charcoal pencils, media which give a textural line in sympathy with the texture of cliffs and rocks. Touches of gouache were used to adjust the shape of light tones on some of the rock faces, but most of the original ink washes remained untouched.

Coloured Wax Crayon and Ink

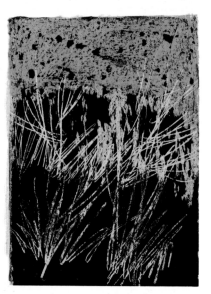

An interesting form of drawing can be obtained by brushing black Indian ink over coloured wax crayons, letting it dry and then scratching through the ink with a knife or a razor to reveal lines of the underlying coloured wax. The amount of wax worked into the paper makes a difference to the adherence of the ink and appearance of the scratched parts.

Fig 1: To start with, I covered a smooth paper with lines of varied colours of wax crayon, keeping the crayoned lines loose and fairly open.

Fig 2: This shows the process of covering the coloured wax with ink. I brushed on plenty of ink until the image was completely covered.

Fig 3: This is a separate little doodle where I have applied orange wax crayon very thickly at the top and yellow wax crayon lightly towards the bottom of the paper. The subsequent ink wash is almost entirely repelled where the layer of wax is dense, giving a pleasing mottled effect. A razor blade was used to scratch the ink to reveal the yellow wax crayon.

Fig 4: The culmination of Figures 1 and 2 is shown here, where I scratched through the dried ink to produce the illustration of a rocky shore. Notice that the direction of the scratched lines helps to describe the planes of the rocks, and in the sky and foreground areas I used the side of the razor blade to remove large amounts of ink.

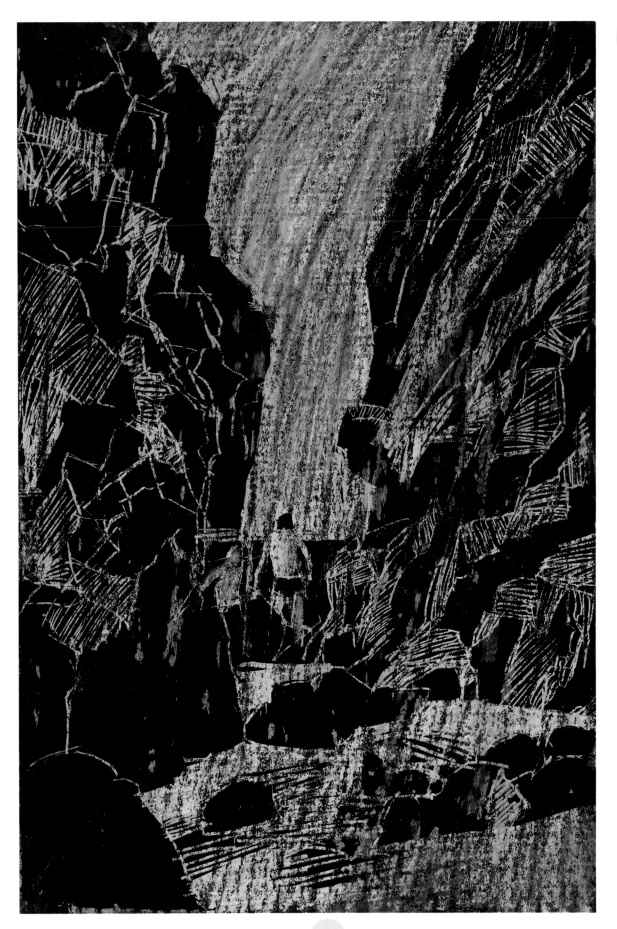

Exploring Colour

Soft pastel, because of its purity of pigment, is an ideal medium for exploring colour. The pastel drawings shown below started off as doodles without particular direction. I decided to 'let go' and draw with colour, exploring the properties of colours that are opposite each other on the colour wheel – these are also known as complementary colours. My choice was purple and yellow, and I started by placing patches of these colours at random, aware at the same time that yellow requires a relatively small amount of purple to create a balance.

Seated Nude ▷

The exploration of opposite colours is introduced into this experimental pastel drawing of a seated nude. Using the yellow and purple theme, I chose a bright yellow Ingres paper and worked in three tones of purple, introducing pale green to harmonise with the yellow. The figure is expressed with minimal drawing lightly applied, with a feeling of sensitivity which is emphasised by the aggressive pastel strokes in the background.

Still Life with Bottles and Cherries ▽

The second of these colour doodles based on yellow and purple also developed into a bottle and fruit still-life theme. Both complementary colours are extended tonally and there is more emphasis on mixtures of purple and yellow. Subtle variations in complementary colours can also be found by extending slightly into the colour wheel each side of the basic colour. For instance, a warm orange-yellow will find blue-purple to be its complementary colour. Similarly, a cooler yellow-green will have a warm reddish-purple as its complementary.

Purple and Yellow Still Life ▽

These random areas of purple and yellow gradually took on connotations of reality, and were developed into a still-life group of bottles and fruit. Placing complementary colours against each other gives maximum intensity and vibrancy to the image, and to link these opposites I added some areas of graduated mixtures of yellow and purple.

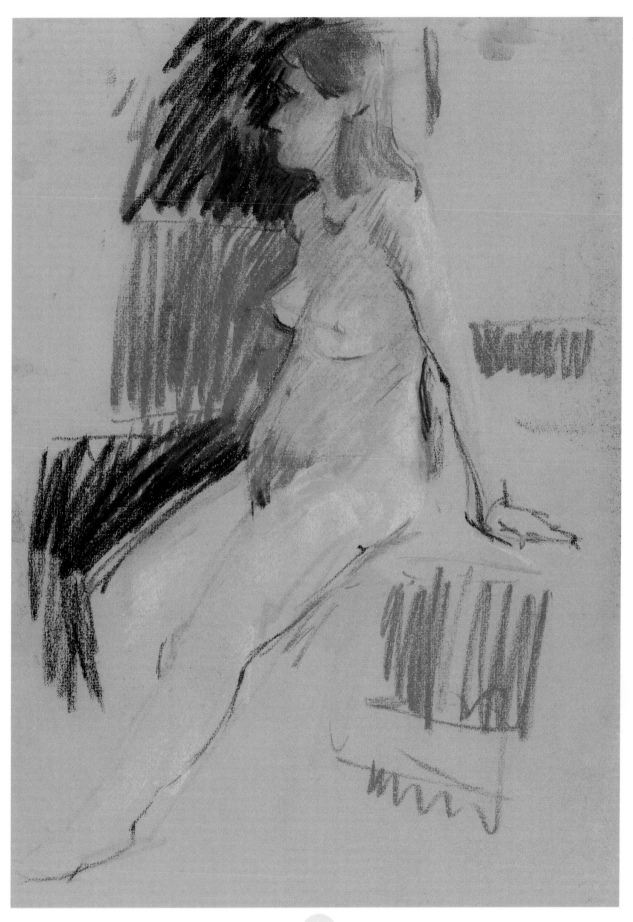

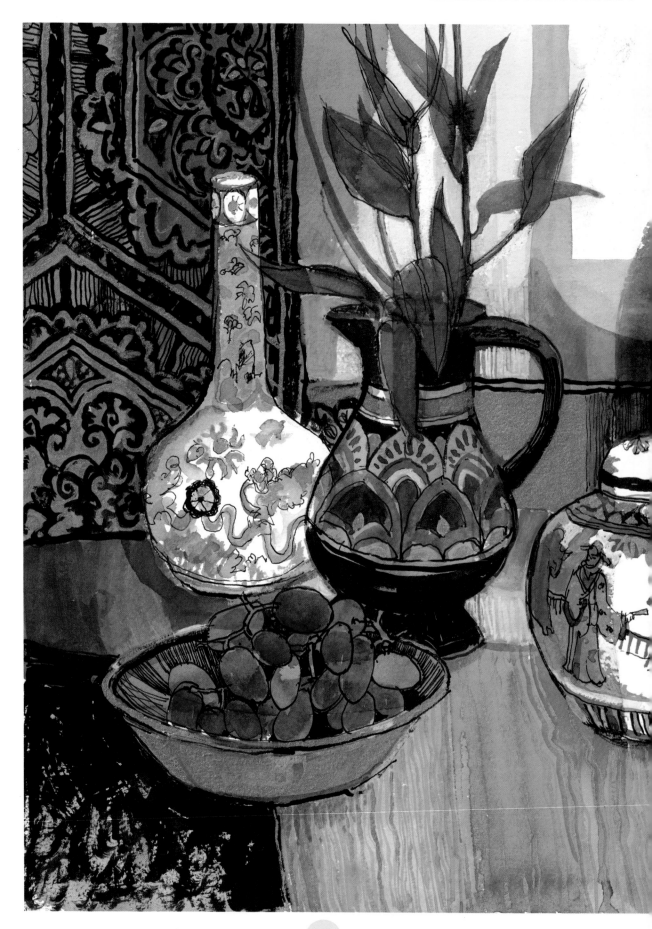

In Conclusion

The scope of drawing has broadened today with such a wide choice of media available, the only limitation being that of compatability. For the artist, an occasional change of direction can be stimulating and lead to new concepts. A mixture of media is worth trying, for it can provide a way of working hitherto untried that may suit you and give new energy to your drawing. But whatever the medium, we seek a sureness and proficiency, accuracy and perception in our drawing, while at the same time trying to capture the emotional character of the subject.

Still Life with Decorative Pots

This decorative drawing with pen and brush on 200lb (425gsm) watercolour paper combines watercolour and gouache with black Indian ink and gold ink. Although apparently colourful the work is, in fact, produced with a very limited colour range comprising cadmium red, alizarin crimson and Payne's grey watercolour, white gouache and black ink applied with a pen, stick and brush.

The underpainting commenced with washes of the two reds, modified in parts with Payne's grey. This overall bright colour provides a base for the decorative drawing made with black ink, some of it applied with a dry brush to give a lithographic character to the image. Strong contrast is achieved by leaving white paper for the pots and part of the background. Finally, the drawing was enriched with gold ink dry-brushed over part of the red ground, and worked with a small brush to embellish the pots and material.

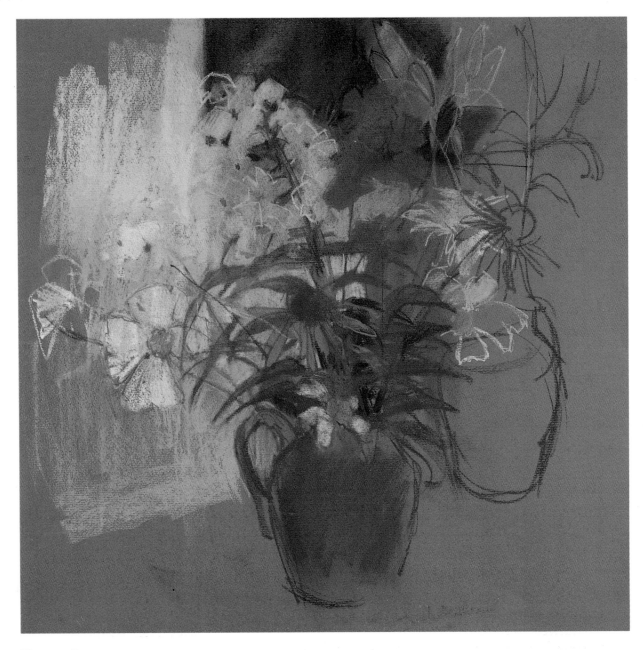

Flower Group

INDEX

Page references in *italics* indicate illustrations

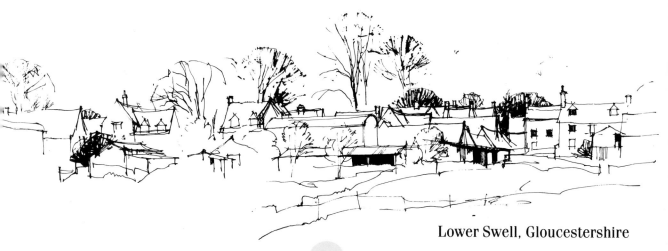

Lower Swell, Gloucestershire

Sheigra, Sutherland